FILM AND TELEVISION STAR CARS

Collecting the Diecast Models

Paul Brent Adams

AMBERLEY

*To Nadine Ackermann, whose help, support, and encouragement
have meant so much – thank you.*

First published 2016

Amberley Publishing
The Hill, Stroud
Gloucestershire, GL5 4EP

www.amberley-books.com

Copyright © Paul Brent Adams, 2016

The right of Paul Brent Adams to be identified
as the Author of this work has been asserted in
accordance with the Copyrights, Designs and
Patents Act 1988.

ISBN 978 1 4456 6210 7 (print)
ISBN 978 1 4456 6211 4 (ebook)

British Library Cataloguing in Publication Data.
A catalogue record for this book is available from
the British Library.

Typesetting by Amberley Publishing.
Printed in the UK.

Contents

Introduction

A Star Car is any vehicle – car, motorcycle, van, truck, bus, aeroplane, helicopter, boat, ship, submarine, or spacecraft – used in a film or television programme, especially if it plays a major part in the action. Typically, it is the car driven by the hero. The term 'Star Car' has been around since at least the 1980s, perhaps earlier. Another term is 'Character Car'; and, in America, the terms 'Hero Car' and 'Villain Car' are also used. Many of these vehicles have become major film and television stars in their own right. It would be hard to think of James Bond without his Aston Martin; Batman without the Batmobile; or the Duke boys without the General Lee, their bright orange Dodge Charger.

Toy and model versions of these vehicles, in a variety of sizes and materials, have been produced so that fans can join in the action, mainly since the 1960s. Collecting these small-scale Star Cars has become a popular hobby – I have been collecting them for over twenty years. You may not be able to afford James Bond's actual Aston Martin DB5 from the film *Goldfinger*, but you can own a model of it – and just about every other car he has ever driven. Literally hundreds of Bond models have been produced since 1965 (with Batman not far behind). Not even the largest car museum in the world could hope to possess all the Bond movie cars, but you can. Nor do you need to mount a bullion heist to pay for your collection; there are many first-class models available at budget prices. You really can afford your very own DeLorean time machine from *Back to the Future*, or the Mystery Machine van from *Scooby Doo*.

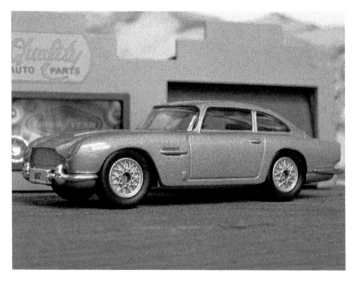

The Aston Martin DB5 first appeared in the third Bond film, *Goldfinger* (1964). In the 1990s, both Johnny Lightning and Corgi released small-scale Bond ranges; scales varied, with the DB5 being 1:53. Length 86 mm.

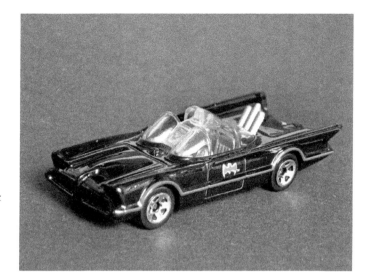

Batman has used many Batmobiles since 1939, his 1960s TV car being the most famous. This Hot Wheels model was first released in 2007, in gloss black with red trim and bat logos on the doors. 80 mm.

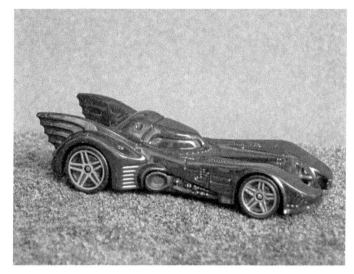

Modern movie Batmobiles are much more sombre, generally being matt black with no markings. This is a Hot Wheels 1989 movie car; by changing the wheels, window colour, and base, numerous variations have been produced. 85 mm.

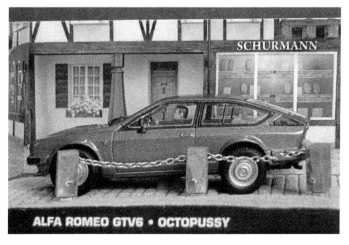

From *Octopussy* (1983), the Alfa Romeo GTV6. All models in *The James Bond Car Collection* partwork came with a small diorama base and printed backdrop, setting each model in its own miniature world.

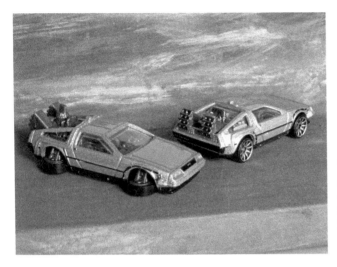

The DeLorean time machine in *Back to the Future* was modified several times across the three films, allowing Hot Wheels to produce different versions. The Hover Mode model runs on concealed wheels. 73 mm.

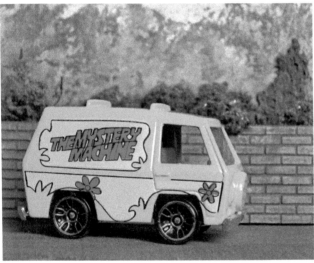

Scooby Doo (1969 onwards) featured a crime-solving Great Dane and his human friends, in a van adorned with flower-power graphics. Hot Wheels modelled the original cartoon version of The Mystery Machine in 2012. 55 mm.

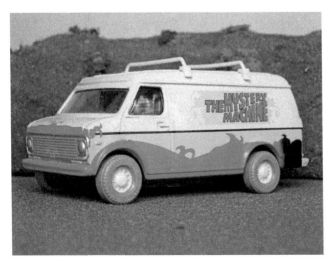

Corgi based their version of The Mystery Machine on their existing Chevrolet Van in 1:36 scale. This was used for several other Star Cars, including those of *The A-Team* and *Charlie's Angels*. 122 mm.

Most of the Star Car models currently available are made of either metal or plastic. Diecast models are widely available, and offer the greatest selection; it is these on which we will concentrate. Early diecasts were all-metal, except perhaps for rubber or plastic wheels, but most modern diecasts also contain plastic parts, including clear-plastic windows.

The Birth of the Diecast

Toy motor vehicles have been around since the earliest days of the real thing. They were made from metals such as printed tinplate, cast iron, pressed steel, lead, wood, or even moulded rubber. Diecast models, produced by pumping molten metal in to heavy metal moulds called dies, appeared just before the First World War. Because the metal is pumped in under pressure, rather than just being poured in, this is sometimes called 'pressure diecasting'. The first diecast cars were made by Dowst Manufacturing in America, but these were isolated models. In the 1920s Dowst expanded their range of vehicles, marketing them under the Tootsietoy brand – a name originally used for dolls' house furniture. Models often came in family groups – Mack trucks or Graham motor cars. These used a number of common parts to keep costs down, but each model had a different body type.

In Britain, Meccano Limited made both Meccano engineering sets and Hornby toy trains. Modelled Miniatures started out as a range of model railway accessories and, in December 1933, they introduced a set of six assorted vehicles, including a tank, a tractor, two cars, and two lorries. These sold well, and the range was expanded. The name Dinky Toys was adopted in 1934. Toy production was interrupted by the Second World War, but resumed once peace returned. Other companies produced similar models, but Dinky was the biggest name in diecast models until the 1950s. Britains, another famous British company, specialised in model soldiers, military vehicles, and farm toys.

After the Second World War, more companies arrived. Lesney Products introduced the smaller Matchbox toys in 1953 – the earliest examples were so small that they really would fit inside a matchbox. The vintage Models of Yesteryear followed in 1956. Corgi, producing Dinky-sized models, arrived in 1956. These introduced clear-plastic windows, but at first only in passenger cars – commercial vehicles were still windowless. The short-lived Spot-on range followed in 1959.

In America, diecast toys never took off the way they did in Britain. Tootsietoys and others could be found, and imports from Britain and Europe were popular, but Americans seemed to prefer the larger-scale plastic kits, which began to appear in the 1950s. It would be the late 1960s, when toy giant Mattel (maker of the Barbie doll) launched Hot Wheels, before small-scale diecasts hit the big time in America. Elsewhere, diecasts were produced by just about every country with any industrial capacity at all, especially those with a domestic motor industry.

Some early diecasts were made of lead, and a few from aluminium, but most are made from an alloy called Mazak, known as 'Zamak' in the USA. It is made up mostly of zinc, with small amounts of aluminium, copper, and magnesium. Some models also had stamped tinplate parts, such as bases and windscreen frames. Plastic parts began to appear in the 1950s, including wheels, windows, and interiors. A major advantage of plastic was that it could be produced in any colour required and so did not need painting, therefore reducing the cost and complexity of manufacturing.

The Arrival of the Star Car

Early toys based on popular book, film, radio, and comic strip characters were common. There were Beatrix Potter stuffed animals, Shirley Temple dolls, Mickey Mouse tinplate toys, and various board games. There were metal figures of popular characters, from Snow White and the seven dwarfs to Dan Dare – Pilot of the Future, from the *Eagle* comic. However, there were very few vehicles tied to any particular character. Vehicles were simply a means for the hero to get around, or to chase the villain. Vehicles had not yet become film or television stars. That would change in the 1960s. James Bond, Batman, and the puppet shows of Gerry Anderson ushered in the era of the Star Car. Toy companies saw this, and began releasing models of these new and glamorous four-wheeled stars.

The first diecast Star Cars seem to have come from America, and were based on newspaper comic strips rather than films (television did not yet exist – it was still being invented). The pioneering Tootsietoys released a short-lived set of six models in 1932, depicting characters from several American newspaper comic strips, or 'Funnies', in various vehicles. A few years later, in 1937, there was a *Buck Rogers* set, containing spaceships from one of the earliest space adventure strips. These were reissued post-war. This set pre-dates the *Buck Rogers* movie serial, which was released in 1939.

The British company Cherilea did some *Journey into Space* figure sets, based on the BBC radio serials of the 1950s. The largest set came with two small spaceships. Another small British company was Morris & Stone, who initially used the name 'Morestone' for their models. In 1956 they introduced a range of Noddy vehicles, based on the children's books by Enid Blyton and first illustrated by Harmsen van der Beek. Now we come to some Star Cars that are actually based on films and television programmes. Westerns were still popular in the 1950s, and many British toy companies had a Wild West line, including Morestone. Their large four-horse Covered Wagon came in various versions, which included 'Walt Disney's Davy Crockett Frontier Wagon' from the Disney films, with the name and portrait of Davy Crockett printed on the real fabric cover. There was also a *Hawkeye and the Last of the Mohicans* version, based on an early Canadian television series. In 1959 Morestone adopted the name 'Budgie Toys', and in 1960 came the *Wagon Train* range, based on another television series. A smaller, two-horse covered wagon was available singly, or in a three-wagon set. In 1962 they produced *Supercar*, from an early Gerry Anderson puppet series.

A range whose name might be confusing is the TV Series, made by Benson Brothers, better known as Benbros. Introduced in 1954, just after the appearance of Matchbox, these were soon renamed 'Mighty Midgets'. These were not Star Cars; they simply came in small boxes resembling a television set.

Despite these early examples and a few others, in both Britain and America, the story of model Star Cars really begins with the British firm of Corgi. The difference was that Corgi would go on to produce a steady stream of new Star Cars – at least two or three new models every year – rather than one or two models or sets per decade. There was always something exciting to look forward to – this is what set Corgi apart.

In 1965 the company brought out *The Saint*'s Volvo P1800, from the television series starring Roger Moore, and the James Bond Aston Martin DB5 from the third Bond film, *Goldfinger*. Both of these were based on existing Corgi models. The Volvo was a

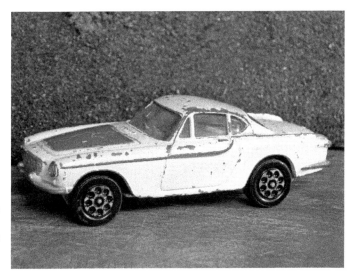

The Saint made his debut in 1928, and moved to television in 1962, where he acquired a Volvo P1800. This became the first Corgi Star Car in 1965. This slightly battered example is the later version with Whizzwheels. 94 mm.

simple repaint of the P1800, which had been in the range since 1962. The DB5 involved modifying the actual dies used to make the earlier DB4, which had been released back in 1960. This had been the first Corgi model to include an opening bonnet and detailed engine. The Bond car lost the engine, but gained tremendous play value with the addition of an opening roof hatch and a working ejection seat for getting rid of unwelcome passengers; a pop-up bulletproof screen to protect the rear window; and extending front bumper over-riders and machine-gun barrels in the front wings. These changes meant that the original DB4 model could no longer be produced. The success of these initial models meant that Corgi quickly expanded their range. Instead of just adapting existing models (which Corgi, and others, still did), they began to invest in new dies, even when these were of no use for any other models.

The following year, 1966, saw the arrival of the first Star Car gift set. Based on *The Avengers*, a surreal British spy show, GS40 contained John Steed's vintage Bentley and Emma Peel's Lotus Elan S2. Again, these were existing models in new colours. The two cars were not available separately in their *Avengers* form, only in this set. The year also saw the first models based on American television shows. The Thrush-buster from *The Man from U.N.C.L.E.* (United Network Command for Law and Enforcement) was another modified model, this time the Oldsmobile Super 88 Sheriff's car from 1962. Thrush was the evil organisation battled by U.N.C.L.E., and was much like SPECTRE in the Bond films. Then came the first Corgi model that was designed from the outset as a Star Car, and which could not be released in any other form. This was the 1966 television Batmobile, which was created by the King of Kustom, George Barris, for the 1966–68 *Batman* television series and spin-off movie. Basing models on American television shows not only ensured the models would sell well in America, a major export market, but also that, as American television programmes were seen in many other countries, the models would sell equally well right around the world. The majority of early Star Cars, from the mid-1960s until the 1980s, were based on long-running, weekly television shows, rather than movies that might be in cinemas for only a week or two, and which most people would see only once. Even the Corgi Bond models were based on a successful series of films. All were made as toys for children, and many had working parts. Most also came with plastic figures.

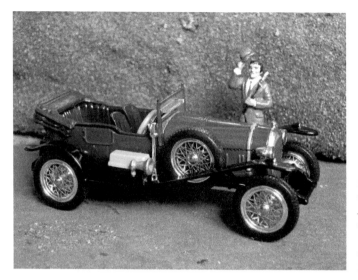

Secret agent John Steed drove a vintage Bentley in *The Avengers* (1961–69). Initially only available in Corgi Gift Set GS40, it was reissued on its own in the 1990s with a metal figure of Steed. 99 mm.

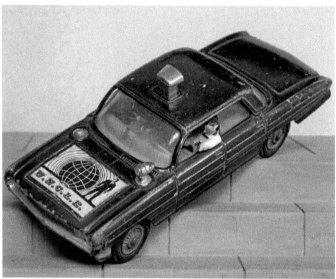

The Man From U.N.C.L.E. was another 1960s spy series. Pressing down on the roof-mounted periscope of the Corgi Thrush-buster made the two figures rock back and forth as they fired at Thrush agents. One spotlight is missing, but easily replaced. 108 mm.

Dinky soon acquired the licence for the various Gerry Anderson puppet shows, from *Thunderbirds* onwards. Unlike Corgi, who had ventured cautiously into the field of Star Cars using existing models, Dinky jumped right in with a purpose-designed model. The first Dinky Star Car was Lady Penelope's pink, six-wheeled Rolls-Royce from *Thunderbirds*. All the models made by Corgi and Dinky were fairly large. Matchbox, the other big name in British diecasts, showed no interest in Star Cars at this time. This left the small-scale Star Car field almost entirely in the hands of Corgi, with their Matchbox-sized Husky and Corgi Junior lines. Huskys had been introduced in 1964, and were sold exclusively in Woolworths stores. A range of small-scale Star Cars, called 'Husky Extras', was added in 1967. When the exclusive deal with Woolworths ended, Huskys became Corgi Juniors, and the Extras were merged into the main Juniors line. The Juniors part of the name was later dropped, but collectors still refer to them as Juniors, avoiding confusion with the larger models.

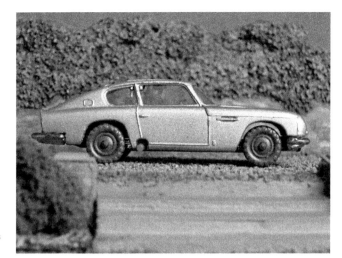

The small Husky version of the James Bond Aston Martin. The red lever on the right side operates the ejection seat. On the larger Corgi models this lever was on the left side. 73 mm.

Kojak (1973–78) was a New York homicide detective with a liking for lollipops and a Buick Regal police car. The Corgi Juniors Regal saw extensive police service; there was also a larger version. 75 mm.

The Return of the Saint (1978/79) revived a successful 1960s series, and gave Simon Templar a Jaguar XJS. Corgi again added his stick figure to the bonnet of both the large and Juniors versions. 75 mm.

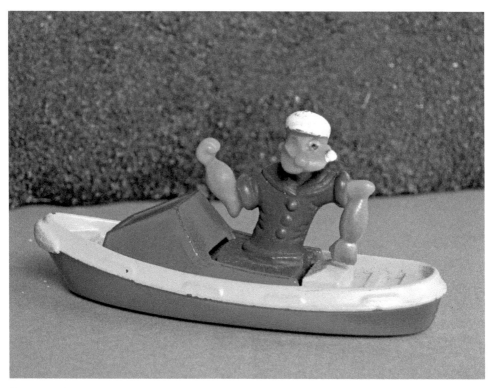

Popeye the Sailor Man made his comic strip debut in 1929. Popeye's Tugboat by Corgi was released in 1980; this waterline model runs on three concealed wheels, and has a plastic half-figure of Popeye. 76 mm.

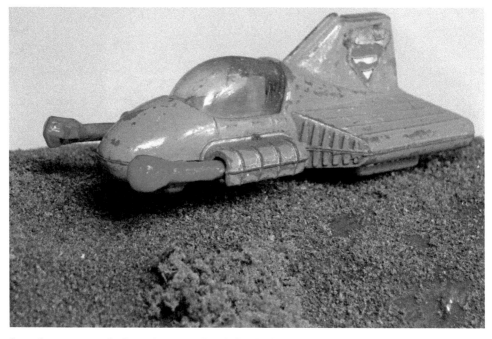

Since Superman can fly faster than a speeding bullet, he hardly seems to need an aeroplane. This Corgi Supermobile has two punching fists, launched by pressing the rear engine exhaust. 76 mm.

A few adults had been collecting diecast models since the early days, and the hobby grew slowly in the post-war years. By the 1960s there were books, magazines, and clubs for collectors, but it was still a specialist hobby. Toy companies took little notice of adult collectors; children and parents were their main market. Small companies, run by enthusiasts, began to appear, producing models that were not available from the big toy makers. By the 1980s, collecting diecasts was becoming more established as an adult hobby and, as toy sales declined, collectors became more important to the toy industry. An increasing number of models were being produced with an eye to such collectors, rather than purely as toys. Older models were also reissued, so that collectors could acquire those that they had missed out on previously. Despite having originally been made as toys for children, the Corgi Classics reissues of many old Corgi Star Cars from the 1990s onwards came with a warning note on the bottom of the box: 'Not suitable for children under 14 years'. Now there are many companies that aim their models solely at adult collectors. Even the toy companies themselves usually have premium lines for collectors. At first Star Cars were looked down upon by 'serious' adult collectors and dismissed solely as toys for children, rather than precise scale models. This ignored the fact that their beloved old Dinkys had also been made as toys. However, as the children who had once played with these toys grew up and became collectors, attitudes changed. Star Cars are now among the most prized of all diecast models – and the most fun.

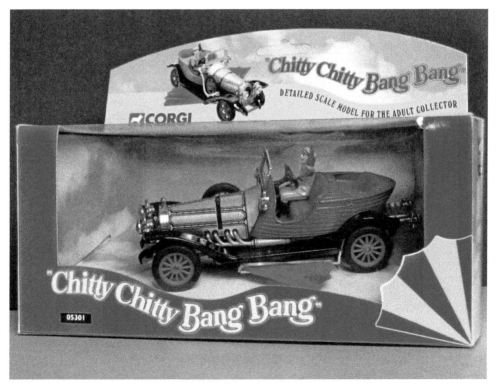

The film *Chitty Chitty Bang Bang* (1968) was based on a book by Bond creator Ian Fleming. Corgi proclaimed their model 'the most fantasmagorical Corgi Toy in the history of everything!'. This reissue has only one figure, and a warning on the box that it is 'Not suitable for children under 14 years'.

Despite the early start by Tootsietoys, not many American companies produced diecasts, and they were slow to enter the Star Car field – although US plastic-kit companies produced many Star Car kits. Most kits were larger than their diecast counterparts. It was only much later that firms such as ERTL, Hot Wheels, and Johnny Lightning begin making diecast Star Cars in any numbers, and these were generally smaller than most British-made models, being similar in size to the Matchbox and Corgi Juniors lines. At the opposite extreme, there are now many very large and highly detailed models in 1:18 scale.

In the 1960s and 1970s, the output of Star Cars was modest, and one could reasonably hope to collect all the models available. Today, there are so many that this would be nearly impossible, especially if you wanted a complete set of obsolete (out of production) models from the past fifty years. This means collectors must specialise: by subject, scale, era, or simply by your favourite shows.

While this book can not cover every Star Car model made over the last five decades, it will give you a good idea of what has been produced, and what is available today, along with tips and advice on looking after your collection. All the models shown are from my own collection, which now numbers several hundred models. Enjoy your new hobby.

Star Cars – The Last Fifty Years

Following the initial releases of 1965/66, 1967 was another busy year for the Corgi Star Cars fleet. There were more new models, gift sets, and the addition of small-scale Star Cars to the Husky line. Things then settled down to a steady two or three new models a year into the 1970s. Dinky were also producing two to three new models a year, with the exception of 1969 when they managed five. Dinky concentrated on Gerry Anderson vehicles, with just a few models from other television programmes, but they were not as keen on sets as Corgi. Another difference was that Dinky did not produce anything based on American television shows until the late 1970s. Finally, they did the Los Angeles Fire Department Paramedic Truck for *Emergency*, a 1972–77 series about a pair of Los Angeles firemen. Despite being from a television series, this model was included in the emergency vehicles section of the catalogue, rather than in the Star Cars section, making it easy to overlook. Some other Dinky Star Cars were also hidden away in odd corners of the catalogue. Their only other American models were from the science-fiction series *Star Trek*.

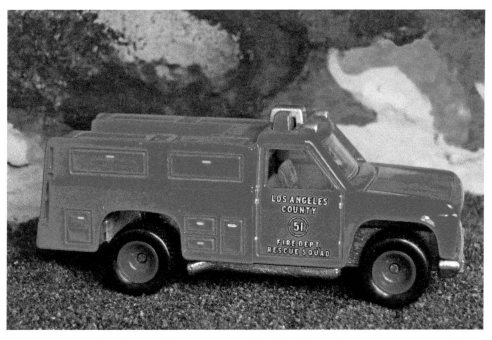

Emergency (1972–77) has been modelled several times. The Hot Wheels Entertainment version of Rescue Truck 51 is smaller than the 1970s Dinky version. 77 mm.

Dinky based nearly all their models on television shows. Their only film models were a pair of Second World War aeroplanes from the film *Battle of Britain* (1969) and Cinderella's Coach from *The Slipper and the Rose* (1976). Corgi also concentrated on television programmes, with only an occasional film model, apart from a steady stream of Bond vehicles. Matchbox still took no interest in film cars. In America, the plastic-kit industry was still busy producing model Star Cars. There were a handful of models from Hot Wheels that were vaguely similar to television cars of the 1970s and 1980s. None of these were official Star Cars, and none really matched the screen vehicles. Emergency Squad (1975) was a red rescue truck, a little like the bigger Dinky model from *Emergency*. Dixie Challenger (1981) was orange and some had a Confederate flag on the roof, like the General Lee in *The Dukes of Hazzard* (1979–85). Baja Breaker was an off-road van with over-sized wheels, but one version was black with a red stripe, and somewhat resembled the one in *The A-Team* (1983–87).

In the 1970s, declining toy sales – usually blamed on the recession, the end of the post-war baby boom, and the arrival of video games – were causing problems throughout the British toy industry. Industrial unrest in Britain early in the decade had a severe effect on industry, leading to a three-day working week and greatly decreased production. This meant that there was only one new large Star Car from Corgi in 1973, nothing at all in 1974, and just one reissue in 1975. Dinky had nothing in 1973, and only one model in 1974. Then things began returning to normal, at least for a time. Sales were still declining and, one by one, the big toy companies fell. Dinky went into receivership in 1979. Matchbox bought the Dinky name in 1987, but only used it for the Dinky Collection, a series of mainly post-war vehicles similar to the pre-war Models of Yesteryear. Corgi and Matchbox also went into receivership in the early 1980s, but changed owners several times and still survive.

During the 1980s most toy production, including diecast models, moved to the Far East, usually China. Hot Wheels have been going strong since 1968 – the bulk of their models have always been produced overseas, usually in places like Malaysia or Thailand. Firms come and go, but there are always new companies to take their place, keeping both children and collectors supplied with new models.

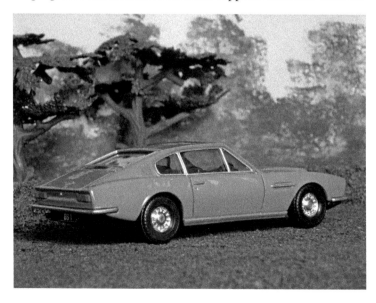

The Persuaders (1971–72) were a pair of millionaire playboys battling crime. Lord Brett Sinclair had an Aston Martin DBS, with BS1 number plates. Corgi, 1:36 scale, 128 mm.

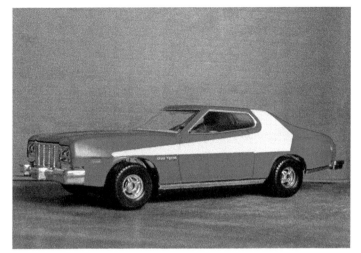

Perfect for undercover police work, the *Starsky and Hutch* (1975–79) Ford Gran Torino. The original Corgi model had plastic figures, while this reissue has metal figures. There was also a Juniors version. 149 mm.

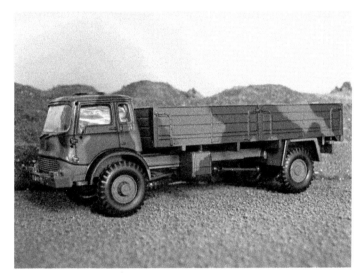

Soldier, Soldier (1991–97) showed life in a modern British Army infantry unit. The Corgi Bedford MK High Dropside army truck came with two small metal soldiers, and a plastic Corgi dog. 150 mm.

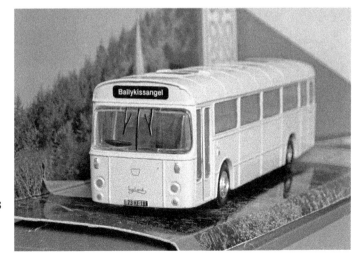

Ballykissangel (1996–2001): a British priest in a small Irish town. Corgi marketed their 1:76-scale buses under the name 'The Original Omnibus Company', including this very plain 1973 Leyland Leopard, with a 'Ballykissangel' destination blind at the front. 143 mm.

For the Bond film *The Spy Who Loved Me* (1977), Corgi produced the Bell Jet Ranger helicopter of villain Karl Stromberg, with twin rocket launchers under the fuselage. The reissue comes with a metal figure. 152 mm.

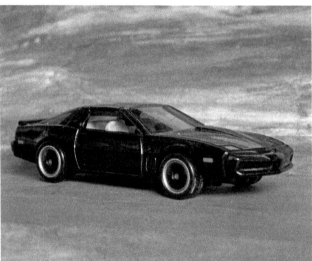

Knight Rider (1982–86) starred K.I.T.T., or the Knight Industries Two Thousand – a computer-equipped supercar. Like many Hot Wheels models, this Retro Entertainment version from 2013 is made in Malaysia. 78 mm.

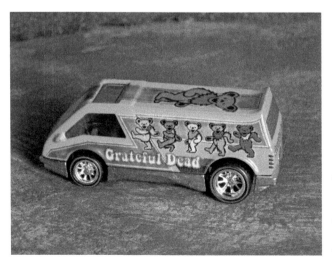

The Grateful Dead, an American rock band, got their own series of six Hot Wheels models in 2014. This Dream Van XGW, with artwork based on an album cover, was made in Thailand. 74 mm.

Matchbox finally began to take an interest in Star Cars in the late 1970s, releasing a dozen Walt Disney models in 1979, all driven by famous Disney characters. These were followed by a few other character, film, and television lines. However, Matchbox never showed the dedication to these models that Corgi and Dinky had, and most models were simply existing castings in new colours and packaging. An exception was a range of small-scale Gerry Anderson models from *Stingray* and *Thunderbirds* in the early 1990s. Matchbox were sold to Universal Toys of Hong Kong in 1982, and subsequently to the American company Tyco in 1992. Matchbox then launched Matchbox Collectibles, a range of more detailed and higher-priced models aimed at collectors. The line included a mixture of miniatures; the larger vintage Models of Yesteryear; buses; and a range of trucks from the Convoy series. There were a number of film- and television-related lines, including the Star Car series, which used existing Matchbox models in suitable packaging. The Character Car collection was similar, but each model came with an over-sized plastic figure from the film or television show on which the model was based. There were also buses carrying graphics for various shows. Tyco was sold to Mattel in 1997, and Matchbox soon went back to making toys for children. Since the Collectibles days, Matchbox have produced only a handful of Star Cars, although 1997 and 2015 each saw a large number of models being produced for the latest *Jurassic Park* dinosaur movie.

In 1983, a new British firm, Lledo, released its first models. Founded by Jack Odell, previously of Matchbox, the name of the company was simply his last name spelt backwards. Early releases in the Days Gone range were all horse-drawn vehicles, but they soon moved on to motor vehicles, and the series eventually went up to the 1940s. When Lledo expanded into the 1950s and 1960s, they used the name 'Days Gone Vanguards' for the more recent vehicles, even though they were mixed in with their pre-war counterparts. Pre-war Days Gone and post-war Days Gone Vanguards models were also mixed together in various sets, some of them film or television related. This changed in 1996, when the Vanguards name was reserved for a range of more detailed and expensive models aimed at collectors. The new Vanguards line only included a handful of Star Cars. The original post-war Vanguards were then fully merged into the Days Gone range, which now went up to the 1960s. Lledo were sold to Corgi in 1999, who only kept the Lledo name for a few years before dropping it. Many of the actual models then became part of the Corgi range.

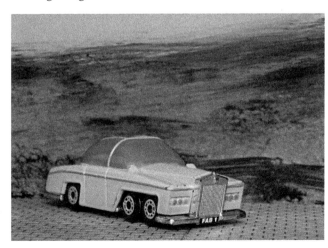

In 1992 Matchbox produced a range of small-scale models from the Gerry Anderson puppet series *Thunderbirds* (1965–66), including FAB 1, Lady Penelope's pink Rolls-Royce. The car has also been modelled by Dinky and Corgi. 80 mm.

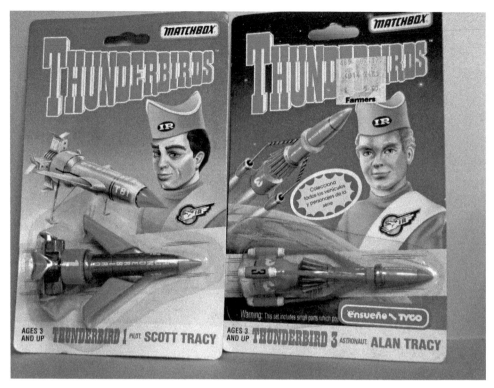

Thunderbirds 1 and 3 by Matchbox, still on their cards. These craft had not been made by Dinky in the 1960s, but both would be produced by Corgi for the fiftieth anniversary of the show.

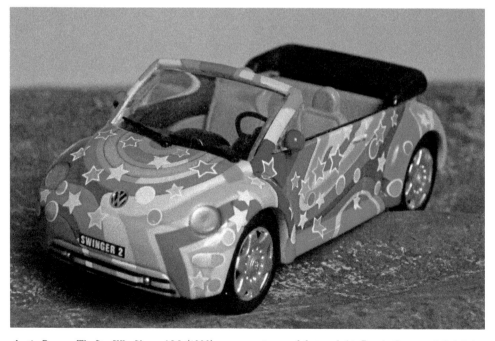

Austin Powers: The Spy Who Shagged Me (1999), a spy movie spoof, featured this Beetle Concept 1 Cabriolet. It has the names Mattel, Matchbox, and Dinky on the base and Matchbox Collectibles on the box. 89 mm.

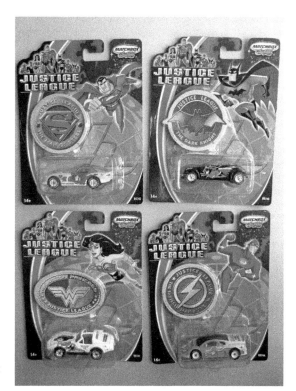

The Justice League was a DC Comics superhero team, consisting of Superman, Batman, Wonder Woman, and The Flash, all of whom were included in this Matchbox Collectibles set.

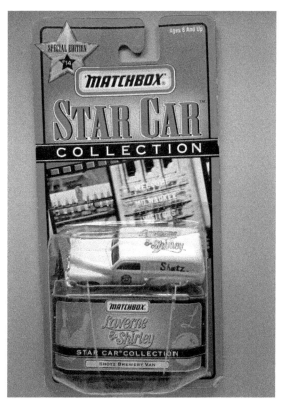

The Matchbox Collectibles Star Car Collection included single models from a range of television shows and movies. *Laverne & Shirley* (1976–83) worked at Shotz Brewery – hence this delivery van.

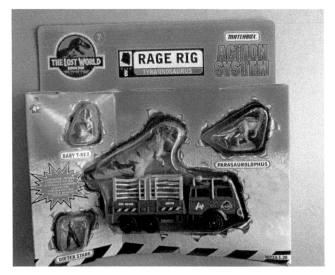

The Lost World: Jurassic Park (1997) was the second film in a series of dinosaur movies. Matchbox produced several vehicle and figure sets for the film, including this Rage Rig Tyrannosaurus.

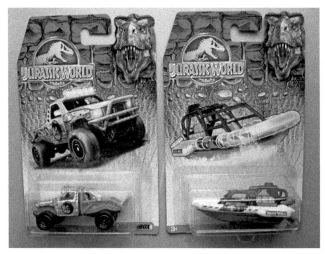

Jurassic World (2015) was the fourth of the *Jurassic Park* films. Matchbox produced individually carded models, as well as larger sets. All were existing models, with either the *Jurassic World* title or dinosaur logo on the side.

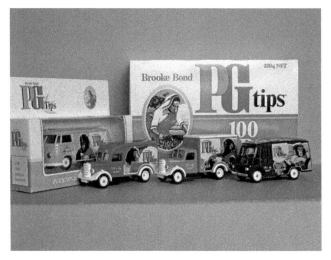

British company Brooke Bond used television commercials starring chimpanzees to sell PG Tips tea for half a century. This Lledo set of four models came in boxes matching those used for the actual tea.

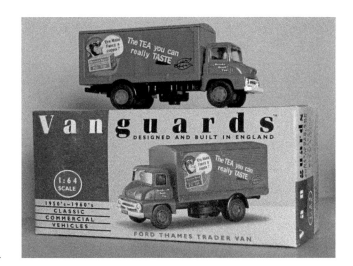

The Lledo Vanguards range included 1:64-scale commercial vehicles, such as this Thames Trader delivery truck with a PG Tips chimp on the side. 107 mm.

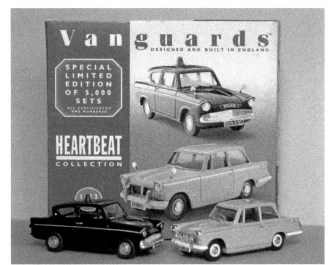

From 1996 Lledo reserved the Vanguards name for models aimed at collectors, including this two-car set for the police series *Heartbeat* (1992–2010), which was set in the 1960s. It contains a Ford Anglia and a Triumph Herald.

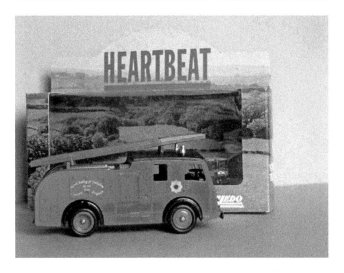

There was also a *Heartbeat* series using regular Lledo models, including the 1955 Dennis F8 fire engine that had been part of the original post-war Vanguards range.

The Lledo Star Car line-up was largely British. Few models actually depicted vehicles used on screen; they were simply typical of an era, or carried names associated with the show. I am particularly fond of Lledo models, as it was their *Goodnight Sweetheart* series, based on the adventures of a time-travelling television repairman, that ignited my interested in collecting diecast models, and especially Star Cars. Thank you, Lledo.

Generally, Lledo Star Cars were released in sets, usually of four to six models. Most were, as usual, from various television shows. Lledo had a particular problem here – as their models only went up to the 1960s, they were limited to shows set in the past rather than the present day. Even when they did a series based on the long-running soap opera *Coronation Street*, set around Manchester, they had to go back to the early days of the show, which had begun in 1960. A further series of four models depicted vehicles from the local Newton & Ridley brewery, all of these being steam powered, and definitely pre-war. Most other Lledo models were from shows with a period setting, such as *The House of Eliott* (1991–94), which was about two sisters in the 1920s running a fashion house; *Dad's Army* (1968–77), set in the Second World War; or *Heartbeat* (1992–2010) a police series set in the 1960s.

The British *Carry On* comedy films had started with *Carry On Sergeant* in 1958 and ended with *Carry On Columbus* in 1992, giving a total of thirty-one films, plus a television series and several Christmas specials. Lledo produced a set of six *Carry On* models in 1999, some of them adorned with miniature film posters. A nice touch was that the models matched the subject of each film; so the poster for *Carry On Matron* (1972) was displayed on the side of an ambulance, while the taxi from *Carry On Cabby* (1963) just had the company name 'Speedee Taxis' on the side.

Another British company, Oxford Diecast, was founded in 1993. It began making diecasts in 1:76 scale, matching OO model railways. They later expanded to 1:43, and then 1:148 scale, thus keeping O- and N-gauge railway modellers happy. Several Star Cars have appeared in the range, but are not usually labelled as such. These are Star Cars nonetheless, as even the number plates match.

In America, ERTL was founded in 1945 by Fred Ertl Snr. Based in the farming state of Iowa, they started out making model tractors and farm machinery before branching out into Star Cars. Johnny Lightning was launched by Topper Toys in 1969, following in the tyre tracks of Mattel and Hot Wheels.

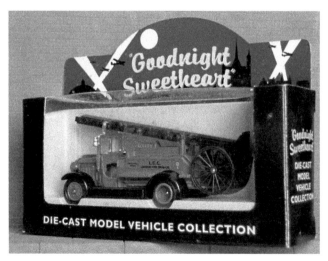

Goodnight Sweetheart (1993–99) transports its hero back to the Second World War. The Lledo box art is based on the opening credits, but the models are simply typical of the period, including this 1934 Dennis fire engine in wartime grey. 98 mm.

A regular in any Lledo set is a brewery delivery vehicle, this being a 1936 Ford Stake Truck from *Goodnight Sweetheart*. Loads varied, depending on the livery; this one has barrels. 91 mm.

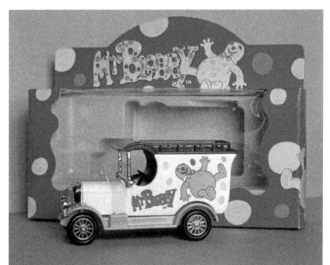

Mr Blobby was a character on the British variety show *Noel's House Party* (1991–99), and appeared on several Lledo models, including this 1926 Morris Bullnose Van. 82 mm.

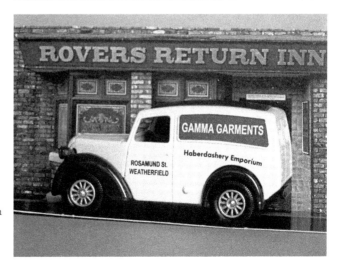

For the Lledo *Coronation Street* set, the usual cream plastic tray holding the model was replaced by a clear tray and a printed card insert depicting the Rovers Return pub. Gamma Garments was a local firm. The model is a 1950 Morris Z Van. 82 mm.

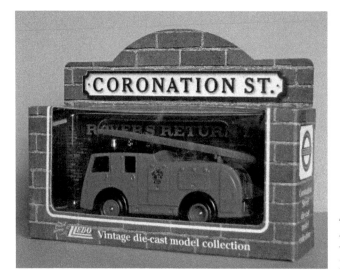

The Lledo *Coronation Street* boxes were excellent; this one holds a Weatherfield District Fire Service Dennis F8. 92 mm.

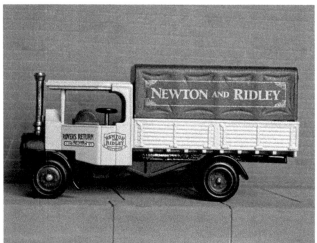

Lledo also produced a vintage *Coronation Street* set in pink boxes, consisting of four steam lorries belonging to local brewery Newton & Ridley – they are definitely pre-war, dating from well before the series began in 1960.

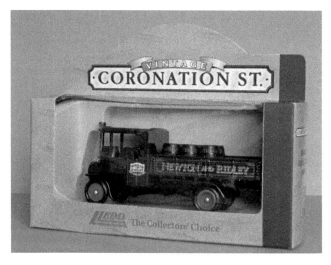

The Foden Steam Wagon appeared twice: in different colours; with a canvas tilt; and with an open back and a load of barrels. 99 mm.

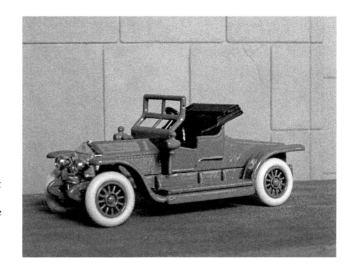

The House of Eliott (1991–94), set in the 1920s, was a perfect series for Lledo, given their large range of veteran and vintage models – such as this 1908 Rolls-Royce Silver Ghost coupe. 78 mm.

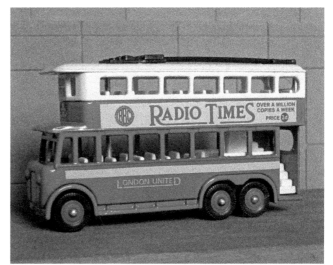

Lledo also produced many bus models, and included one in most of their Star Car sets, including this 1928 Karrier E8 Trolley Bus from *The House of Eliott*. 93 mm.

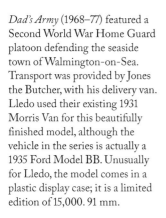

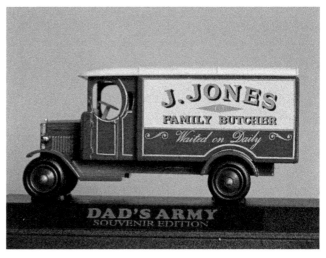

Dad's Army (1968–77) featured a Second World War Home Guard platoon defending the seaside town of Walmington-on-Sea. Transport was provided by Jones the Butcher, with his delivery van. Lledo used their existing 1931 Morris Van for this beautifully finished model, although the vehicle in the series is actually a 1935 Ford Model BB. Unusually for Lledo, the model comes in a plastic display case; it is a limited edition of 15,000. 91 mm.

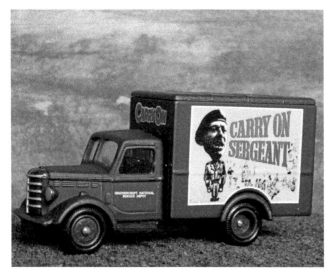

Starting with *Carry On Sergeant* (1958), the *Carry On* film series ran until 1992. Lledo did not do many movie-related models, but did produce a *Carry On* set, which included this 1950 Bedford 30-cwt Army truck with future *Doctor Who* star William Hartnell on the side. 95 mm.

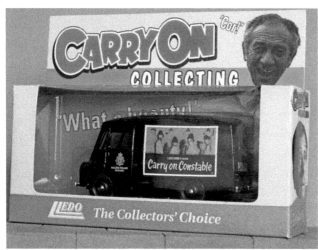

'Carry on Collecting' – excellent advice from Sid James, who joined the team for their fourth film, *Carry On Constable* (1960). Morris LD150 police van. 83 mm.

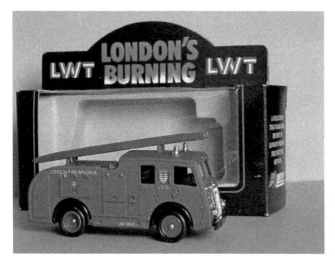

London's Burning (1988–2002) saw British firemen in action. The Lledo Dennis F8 fire appliance gets another outing. It appeared in several Star Car sets, as well as real liveries.

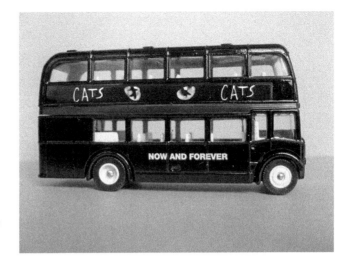

Lledo produced a set of four 1957 Bristol LD6G Lodekka double-decker bus models depicting London stage musicals by Andrew Lloyd Webber, including *Cats*. 95 mm.

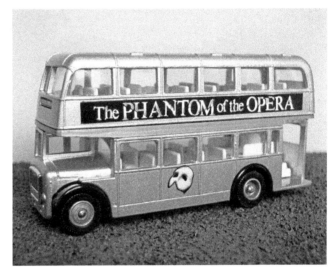

The other musicals in The London Experience series were *The Phantom of the Opera*, *Jesus Christ Superstar*, and *Starlight Express*.

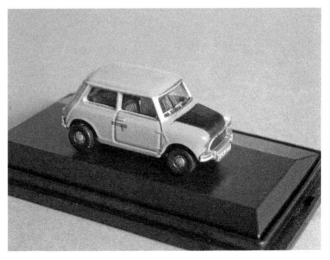

The accident-prone *Mr Bean* (1990–95) drives a Mini, with a bolt and padlock on the door. Most models have this simply printed on, including the Oxford Diecast version. 41 mm.

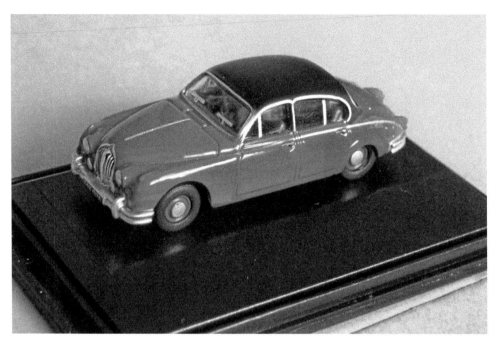

If there are any murders on your OO model-railway layout, *Inspector Morse* (1987–2000) and his Jaguar Mark II saloon will be on hand to solve them, thanks to Oxford Diecast. 60 mm.

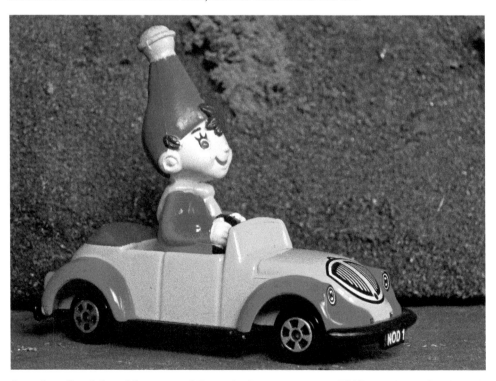

Apart from British firms Morestone and Corgi, the American company ERTL has also produced Noddy models. Large plastic figures are common among toys aimed at young children. The wheels on this model are unusually small. 77 mm.

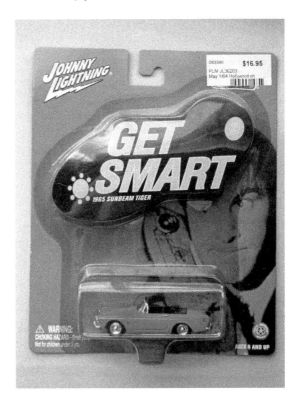

In *Get Smart* (1965–70), fearless but bumbling secret agent Maxwell Smart battles the forces of evil. Johnny Lightning included his 1965 Sunbeam Tiger in their Hollywood on Wheels line.

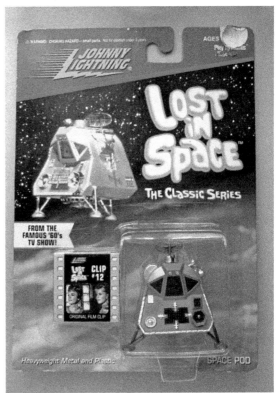

Lost in Space (1965–68) saw the Space Family Robinson get lost on their way to Alpha Centauri. Johnny Lightning produced a set of four models that included the Space Pod, which was very similar to the Lunar Module used in the real Moon landings.

Topper went bankrupt in the early 1970s, but the Johnny Lightning name was revived by a company called Playing Mantis in 1994. Their initial range of muscle cars and customs was expanded to include Star Cars, including the Hollywood on Wheels line. This is yet another company that changed hands several times; it disappeared briefly, but then reappeared.

Like Matchbox, Hot Wheels did not initially take much interest in Star Cars, apart from a few special sets related to various films and television programmes. Finally, in 2004, the first official Star Cars began appearing in the main toy line. Initially, this was limited to a few Batman models, but in 2010 the company included its first non-Batman model in the mainline. This was Ecto-1, the converted Miller-Meteor Cadillac ambulance from the *Ghostbusters* films. From now on there would be new Star Cars every year. Soon the range expanded to the point where they comprised their own sub-series within the mainline. New additions were mixed with reissues of older models, usually in slightly different versions. Cartoon-based models also got their own sub-series, as did Batman. Even so, not all Star Cars are to be found within the over-flowing ranks of the Screen Time, Tooned, and Batman ranges. The Aston Martin DB10, from the Bond film *Spectre* (2015), is included in the Showroom series. Hot Wheels also continue to produce special lines that tie in with movies, television characters, or comics. These are usually standard models from the toy line, painted and decorated with suitable graphics. In addition, Hot Wheels have several other toy lines that sometimes contain Star Cars. There is the Monster Jam series of monster trucks, which comprise a common chassis with outsized wheels, fitted with various bodies. The Color Shifters changed colour when exposed to the heat or cold. There are also motorcycles, some with riders. The five-pack range has also included several different Batman sets. Hot Wheels have also done some larger-scale models, some of which are not available in the smaller sizes.

The first official Star Cars appeared in the Hot Wheels Mainline in 2004: a group of four Batmobiles, including this twin-canopy type in purple and black. 86 mm.

Hot Wheels were going through one of their weird phases when they introduced the short-lived Hardnoze and Crooze lines. This is the Hardnoze version of the 1989 movie Batmobile, with a giant nose and short tail. 82 mm.

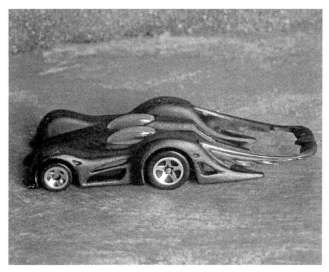

Half the 2004 Batmobiles were in these styles, with the Crooze series having short noses and very long tails. 86 mm.

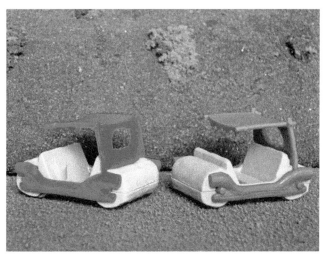

The Flintstones (1960–66) showed what life was like in Stone Age suburbia. In 2013 Hot Wheels modelled the cartoon Flintmobile, which runs on concealed wheels. 51 mm.

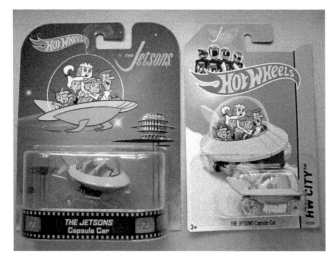

The Jetsons followed on from *The Flintstones*, and depicted life in Space Age suburbia. The family Capsule Car was available in both Hot Wheels mainline and Entertainment versions.

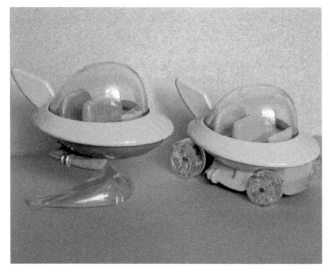

The mainline Capsule Car runs on wheels, while the more accurate Entertainment version has a different lower body, and comes with a display stand. 57 mm.

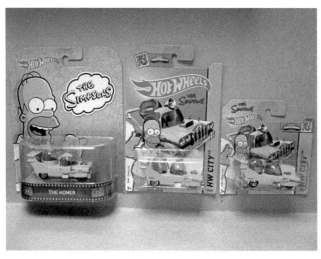

Card variations for the Hot Wheels Homer: Entertainment, Mainline long card, and Mainline short card. The latter is found mainly in supermarkets.

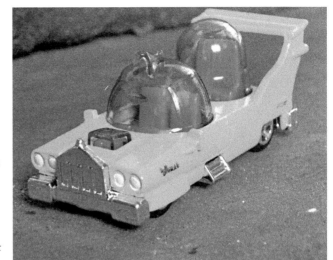

Homer Simpson himself designed the Homer for his brother's car company – which then went bankrupt. It appeared in only one episode of *The Simpsons* (1989 onwards), in 1991, so we are very lucky to have this model from Hot Wheels. 71 mm.

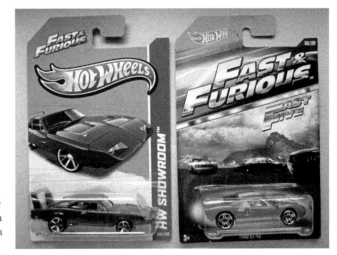

Hot Wheels gave *The Fast and the Furious* movies their own series on special cards, as well as including a few models in the mainline.

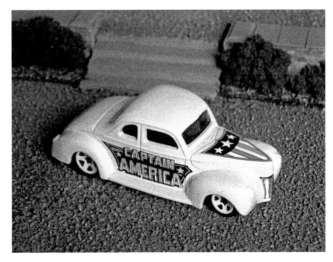

Costumed superhero Captain America first appeared in 1941. This Hot Wheels series depicts variations of the name from across the decades on a range of vehicles, such as the '40 Ford Coupe. 74 mm.

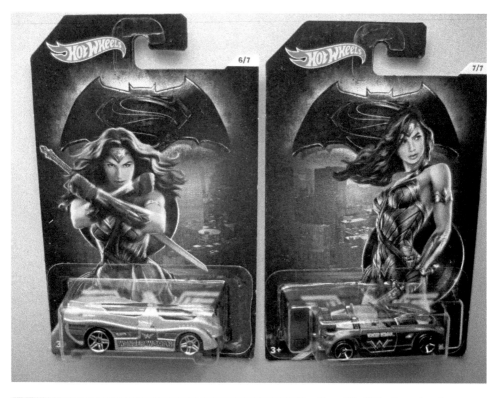

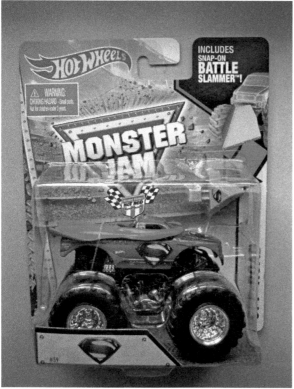

Above: Hot Wheels produced a seven-vehicle *Batman vs Superman* (2016) range, with two of the models being devoted to Wonder Woman, who had made her comic debut in 1941. Power Pistons and Tantrum carried her new gold and bronze colours.

Left: Hot Wheels produce a line of Monster Trucks, the common chassis being fitted with different bodies. This Superman version even has a flowing red cape.

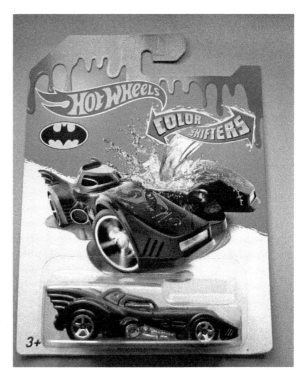

Hot Wheels Color Shifters change colour in warm or icy water, holding the colour at room temperature. This 1989-movie Batmobile has red flames on the nose.

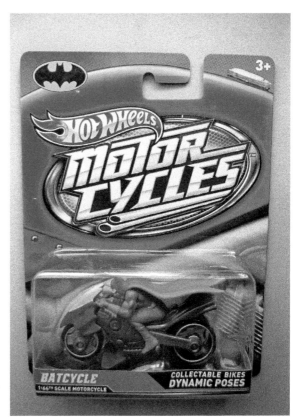

Batman on one of his many Batcycles, part of a motorcycle series by Hot Wheels. The claimed scale of 1:64 is well out, the model clearly being much larger.

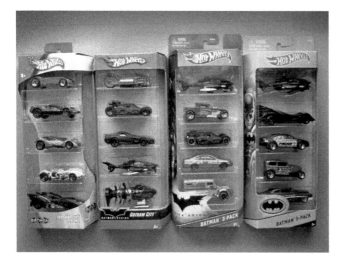

Hot Wheels produce a range of five-packs on various themes, including Batman. Each contains one or two genuine Bat-vehicles, and several regular models in appropriate finishes.

Fathom. This a fantasy submarine introduced in 1998. It was included in the 2007 Gotham City five-pack, masquerading as a Bat-sub. The rotating propellers can be blue plastic, or light blue chrome. 74 mm.

This selection of Gotham City police cars is from various Hot Wheels Batman five-packs. All are standard models in GPD markings. None are available separately.

The Batman five-packs also contain various villain cars. Again, these are standard models, with graphics depicting such nefarious foes as the Joker and Penguin.

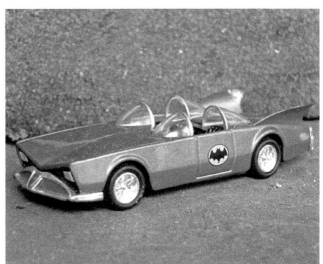

There is a larger-scale Hot Wheels Batman series that includes several models not available in the mainline range, such as this *Superfriends* cartoon Batmobile from the 1970s. 98 mm.

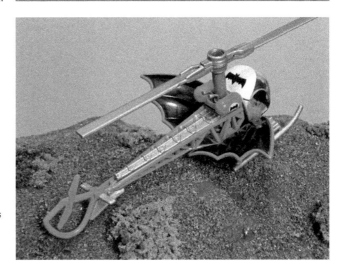

The larger Batman range includes this 1960s TV Bat-copter with wings, based on a Bell 47. The main rotor blades fold.

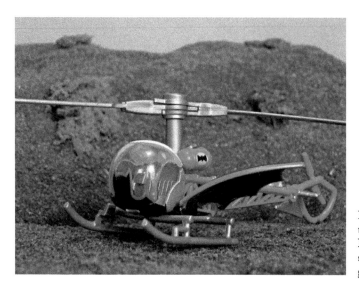

Hot Wheels have beefed up the delicate design of the Bell 47 considerably so as to strengthen it, but it is still a great model. 110 mm.

In addition to the toy lines, Hot Wheels have produced many premium lines aimed directly at collectors. Some include models only available in that series; others are enhanced versions of existing models from the toy lines. Most of these have both metal bodies and metal baseplates, making them much heavier than the mainline versions, which usually have plastic bases, more accurate Real Rider wheels, and more extensive tampo-printed detailing. Most are still packed on cards, but these are slightly larger than the standard Hot Wheels card. As a result, these premium models sell for four or five times the price of a regular Hot Wheels vehicle. Some of the premium lines have included Star Cars, with the Entertainment range being totally devoted to film and television vehicles. The series began in 2013 under the name Retro Entertainment. Nostalgia Brands, a 2011/12 series, featured models carrying artwork that depicted many film and television characters, but they were not vehicles from the actual shows. Not all these models were Star Cars; some depicted chocolate bars or breakfast cereals. In 2013 the name changed to 'Pop Culture', but the mix of subjects remained the same.

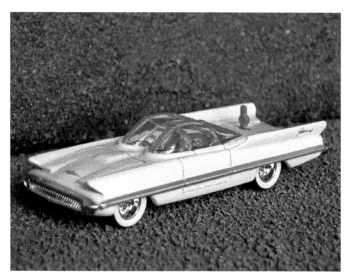

The Space Age 1955 Lincoln Futura concept car arrived two years before the first *Sputnik* was launched. Painted red, it appeared in *It Started With A Kiss* (1959), and then became the TV Batmobile. 81 mm.

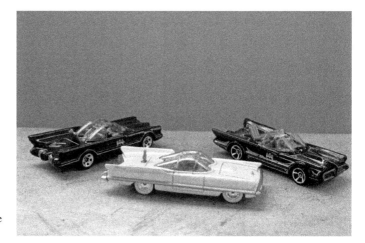

Two slightly different Hot Wheels mainline 1966 TV Batmobiles, and a Hot Wheels Boulevard 1955 Lincoln Futura concept car. They were based on the same real car.

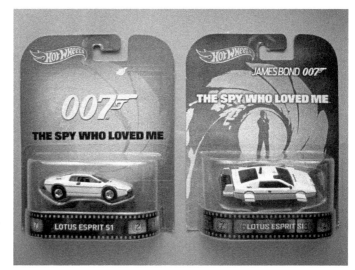

The Hot Wheels Entertainment line has included the Lotus Esprit Bond car in both its road and submarine forms; the road version was also a mainline model.

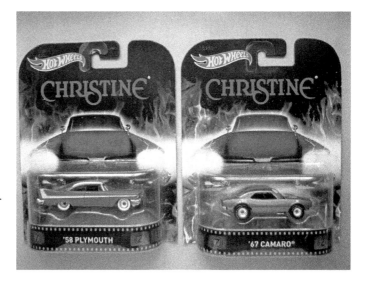

Christine (1983) was the tale of a murderous '58 Plymouth. Hot Wheels produced both Christine herself and a '67 Camaro, using the same card design but in different colours.

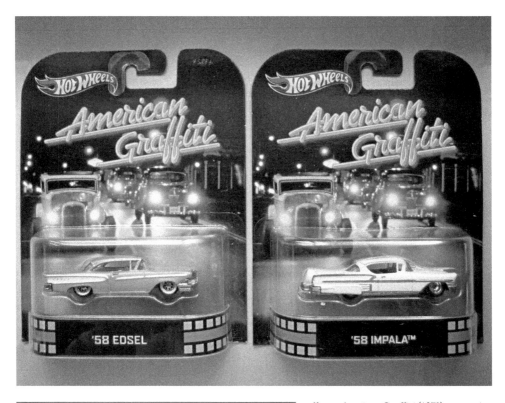

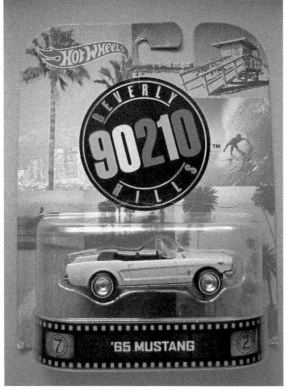

Above: American Graffiti (1973) was set in 1962, but most of the cars were from the 1950s. The Hot Wheels Entertainment line included both the '58 Edsel (stunning in turquoise), and '58 Impala.

Left: Beverly Hills 90210, high-school life in the fast lane. Hot Wheels Entertainment '65 Mustang with opening bonnet.

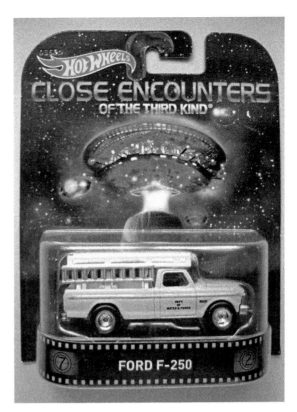

Close Encounters of the Third Kind (1977) sees friendly aliens land on Earth. This is a Hot Wheels Entertainment Ford F-250 pickup in Dept. of Water & Power markings.

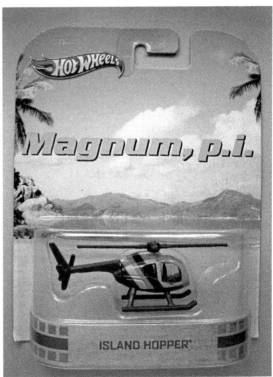

T. C. ran Island Hopper, a helicopter-hire company, but spent most of his time transporting pal Magnum around the Hawaiian Islands. Hot Wheels modelled an early Hughes 500; the series mainly used a later 500D.

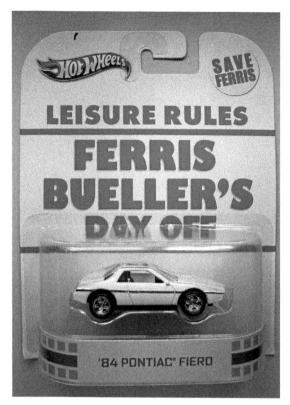

In *Ferris Bueller's Day Off* (1986), young Mr Bueller decides to take the day off school. This '84 Pontiac Fiero is from 2013, when the Retro Entertainment line was launched; it was renamed Entertainment in 2014.

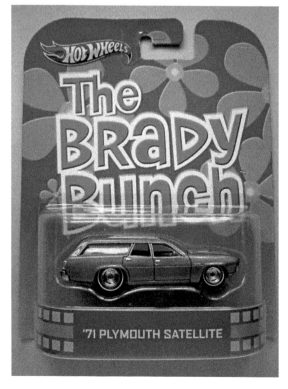

A family of three boys and a family of three girls unite to form *The Brady Bunch* (1969–74). With Mother, Father, and the dog, they really needed this Hot Wheels Entertainment '71 Plymouth Satellite station wagon.

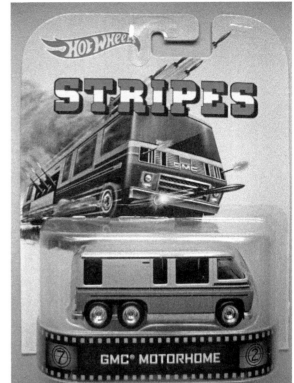

Right: *Stripes* (1981) was an army comedy. The Hot Wheels card shows a GMC Motorhome packed with concealed machine-guns and rocket launchers, which the actual model lacks.

Below: In *Beverly Hills Cop* (1984), a tough Detroit cop arrives in Los Angeles. The Hot Wheels '68 Chevy Nova has been given a well-weathered finish.

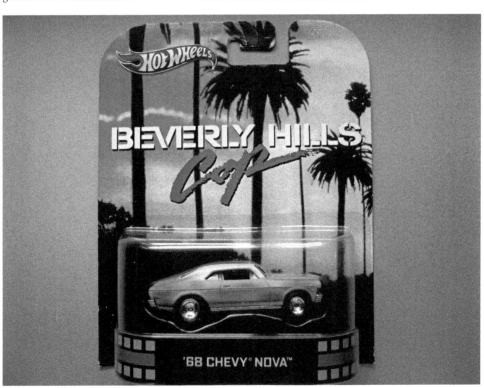

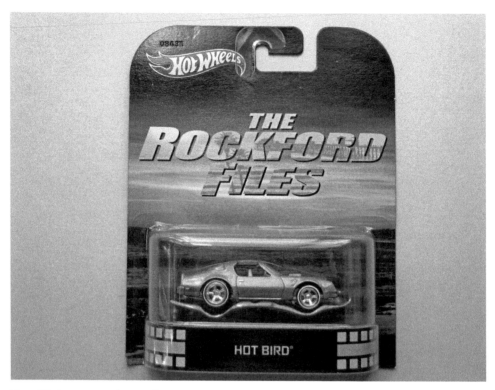

From *The Rockford Files* (1974–80), this is small-time private eye Jim Rockford's Hot Bird – a Pontiac Firebird with an opening hood. Hot Wheels Retro Entertainment, 2013.

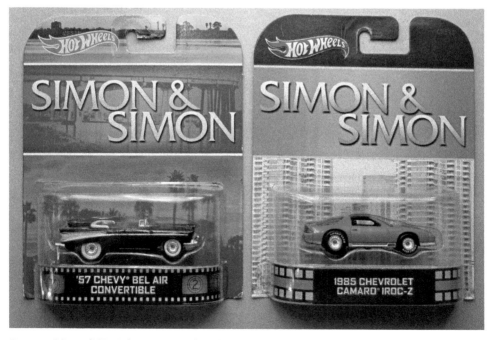

Simon and Simon (1981–88) were a pair of brothers running a private detective agency. These are the Hot Wheels 1985 Chevrolet Camaro IROC-Z and '57 Chevy Bel Air Convertible; there was also a pickup truck.

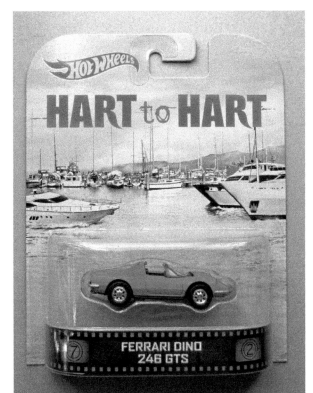

Right: *Hart to Hart* (1979–84) featured a husband-and-wife team of amateur sleuths; pictured is a Hot Wheels Entertainment version of their Ferrari Dino 246GTS.

Below: Hunter Elmer Fudd has been trying to catch Bugs Bunny since 1940. Hot Wheels gave him an '85 Ford Bronco as part of a Pop Culture set of six Looney Tunes characters. 80 mm.

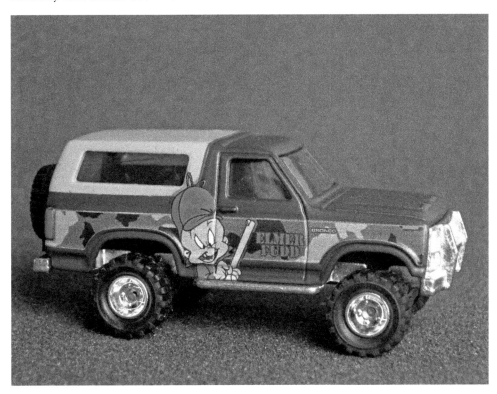

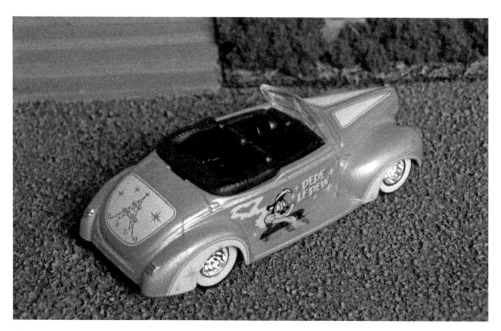

Amorous French skunk Pepe Le Pew joined the Looney Tunes cast in 1945. He drives a pink 1940 Ford convertible, with the Eiffel Tower on the boot lid. Hot Wheels Pop Culture series. 75 mm.

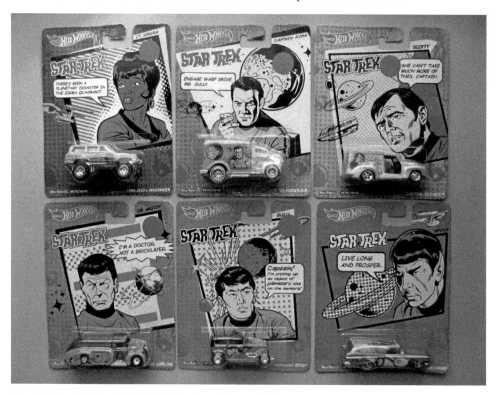

Set of six *Star Trek* models by Hot Wheels, with artwork depicting the original television cast (1966–69). Metal bodies and baseplates, Real Rider wheels, and extensive decoration make these premium models more expensive than mainline toys.

Greenlight is a fairly new arrival. They have produced a good range of American muscle cars, foreign sports cars, and an extensive range of Star Cars in 1:18, 1:43, and 1:64 scales. Aimed at collectors, these are more expensive than Hot Wheels models, and harder to find, but they cover many subjects not made by Hot Wheels. Greenlight have many models based on films and television shows that are aimed at adult, rather than family, audiences. This means that they would be unlikely candidates for a toy line, such as Hot Wheels, although not all Greenlight models are for adults only.

It seems to be mainly British and American companies that make Star Cars. The French firms Solido and Majorette have made a few, but even these are mainly based on American films or television shows. Tomica, the biggest name in Japanese diecasts, have also produced models based on *Batman* and *Back to the Future*, as well as local cartoon and comic book characters. Maisto is a Chinese company that has dabbled in Star Cars from time to time. They once did a range of Marvel superhero models and then a set of Harley Davidson motorcycles from the television series *Sons of Anarchy* (2008–14), about a motorcycle gang. Their output might be limited, but it has been varied. If there are any Star Cars from other countries based on local television programmes, these might not be well enough known internationally to be recognised by collectors elsewhere.

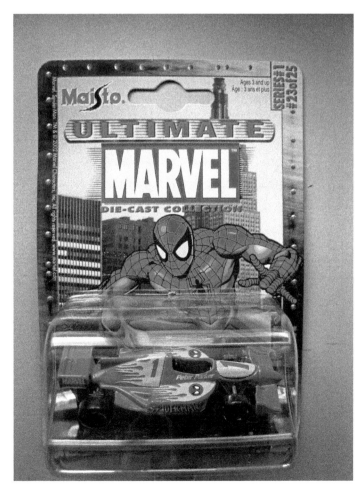

Maisto did an extensive range of Marvel superhero models, including this Matchbox-sized racing car belonging to Peter Parker – Spiderman. Each card had its own unique artwork.

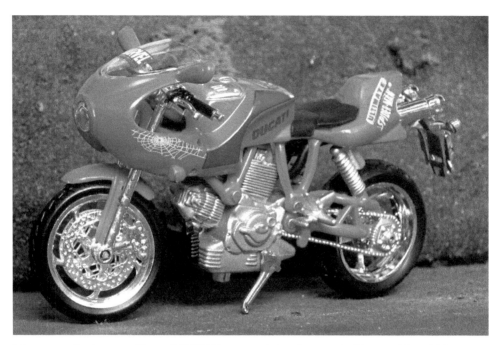

Maisto gave Spiderman a Ducati MH900E as part of their large-scale Ultimate Marvel Motorcycle Collection in 2002. 118 mm.

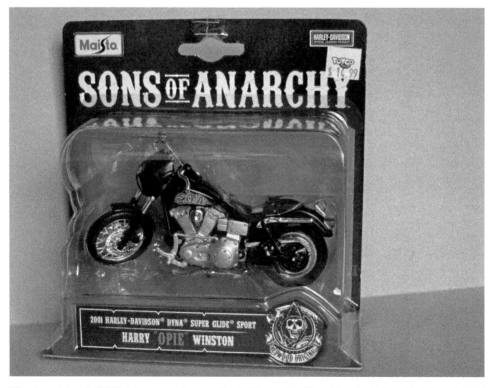

The *Sons of Anarchy* (2008–14) motorcycle gang all rode Harley-Davidson bikes, including this 1:18-scale 2001 Dyna Super Glide Sport by Maisto.

Collecting Diecast Star Cars

New model prices vary from pocket money toys to models for collectors costing hundreds, but there is a good selection whatever your budget, with toy sales being a good time to pick up more expensive items. Vintage models vary enormously, with rarity and condition usually being more important than age. Most of the models in this book are from the lower end of the price scale, and not all could be described as perfect – once upon a time someone actually played with them.

Toys and Models

A toy is a plaything, while a model is a miniature version of something larger. Many early automotive toys were only loose copies of real vehicles. By the 1930s they had become recognisable models of the real thing; and, by the 1960s, when Star Cars began appearing, the levels of detail and accuracy obtained by mass-produced diecast toys had reached incredible levels. The main difference today between toys aimed at children and models aimed at adults is that the former have to be strong enough to stand up to many hours of rough play, while the latter do not. As a result, models for collectors often have many small and delicate parts that are easily broken, and so they must be handled with rather more care than the average toy car.

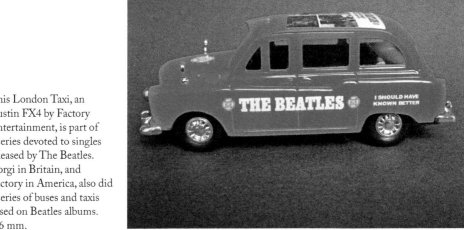

This London Taxi, an Austin FX4 by Factory Entertainment, is part of a series devoted to singles released by The Beatles. Corgi in Britain, and Factory in America, also did a series of buses and taxis based on Beatles albums. 126 mm.

Scale

The only thing you really have to remember about scale is that the larger the number, the smaller the model: 1:43 is larger than 1:64, but smaller than 1:36. Now let's look at things in a little more detail.

Scale is the size of a model relative to whatever it is based on. This is usually given as a ratio (1:64) or a fraction ($\frac{1}{64}$). It can also be given as fractions of an inch, or millimetres, on the model to 1 foot on the real thing, thus mixing imperial and metric measurements. This system has been in use for so long that it is fully accepted and understood. Examples being $\frac{1}{4}$ inch to the foot (1:48), and 4 mm to the foot (1:76). In the world of model railways, letters and numbers are used. As early diecasts were often intended as model-railway accessories, many common vehicle scales match model railway scales: so 1 is 1:32; O is 1:43 in Britain, but 1:48 in America; S (no longer a common railway scale) is 1:64; OO is 1:76; and HO is usually 1:87. Real objects vary in size, from a motorcycle to an aircraft carrier, with smaller subjects tending to be made to larger scales, and larger subjects to smaller scales.

Scales are not always given on the model or on the box, and are sometimes only approximate anyway. Some models are simply made to fit a standard box, and not to any recognised collecting scale. Cars are fairly small, and the main collecting scales are reasonably large. Commercial vehicles and buses, bigger in real life, tend to be made to smaller scales; these are followed by aircraft and ships. Let's take a look at a typical Star Car. The Aston Martin DB5 is 4,570 mm long in real life, or about 15 feet. In the most popular collecting scales for cars, this would be reduced to:

1:18	254 mm	10 inches
1:24	190 mm	7½ inches
1:32	143 mm	5⅝ inches
1:36	127 mm	5 inches
1:43	106 mm	4⅛ inches
1:64	71 mm	2¾ inches
1:76	60 mm	2⅓ inches
1:87	52 mm	2 inches

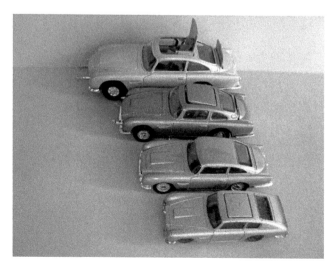

Corgi have made numerous versions of the Aston Martin DB5 in different scales, most of them shown here. The largest model is to 1:36 scale; then 1:43 (actually closer to 1:45); 1:53; and the 1:64 Husky version. Lengths vary from 126 mm down to 73 mm.

The term 'miniature' really applies to any model but, among collectors, it often refers to the smaller models by Matchbox or Hot Wheels, rather than the larger types by Corgi or Dinky. Matchbox-sized models are sometimes loosely referred to as 1:64 scale, even though some are larger or smaller. Some ranges intended for collectors truly are made to a uniform 1:64 scale. The most common size for models aimed at collectors is 1:43. This is approximately the scale to which most Dinky and Corgi cars were made, although actual scales varied. In the 1970s Corgi moved up to 1:36. There has been a trend over the last couple of decades towards really large-scale models, especially 1:18.

Gift sets, and other multi-vehicle collections that contain models of different vehicle types, often mix scales, with some rather odd results.

Rarity

The rarity of a model today depends on how many were made, and how many survive. Toys were made to be played with, and few survived in top condition. Some were more fragile than others. Most show signs of wear, and the majority lack boxes. Toys that were initially unpopular, and did not sell well, usually had a short production life. This now makes them rare, desirable, and more expensive than more popular models, which were produced in greater numbers. Also, the larger and more expensive a toy was originally, the fewer are likely to have been made. Generally, reissues are considered less desirable than originals, although many collectors want to have an example of each. Limited-edition models are produced in fixed quantities, the exact number usually being stated on the packaging. Some include a numbered certificate: a limited-edition model without its certificate is deemed less valuable than one with the certificate. Limited editions usually cost more than unlimited models.

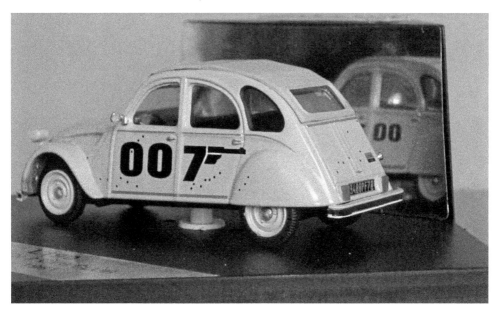

Citroen were so pleased to have their 2CV in *For Your Eyes Only* (1981) that they released a special edition of the real car, complete with 007 logos and fake bullet holes. Vitesse then released a limited-edition model of the full-size limited edition. 88 mm.

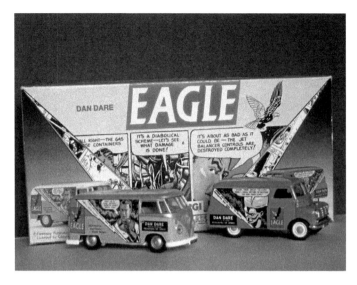

The Eagle was a British weekly comic for boys, launched in 1950. In it, Dan Dare – Pilot of the Future battled the evil Mekon. This is a Corgi two-vehicle set containing Volkswagen and Bedford CA vans. A limited edition of 7,500 sets.

Some Assembly Required – Kits

A kit is a set of parts that have to be assembled to create a finished model – this is the fun part. Most modern kits are made of plastic, with metal or resin being used for models aimed at adult enthusiasts. The earliest plastic kits appeared in the 1930s, but did not become popular until after the Second World War. There are simple snap-together models, with only a few parts, and those with hundreds of parts. Kits can be moulded in several colours to reduce the need for painting, and most have chrome-plated parts. Some kits have extra parts, allowing different versions to be built.

Metal kits are usually just unassembled diecasts, and often come pre-painted. Diecasts are commonly held together with rivets, but kits mainly use screws; many even include a small screwdriver. To a kit collector, 'mint' means unassembled. To actually build the kit, the whole point of its existence, will reduce its value as a collectable.

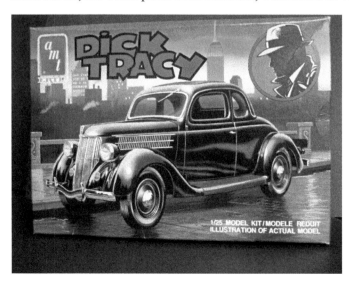

Dick Tracy, who debuted in 1931, was a tough police detective with an array of gadgets. The 1990 movie version saw diecasts from ERTL, and this 1:25-scale plastic kit by AMT, who were then owned by ERTL.

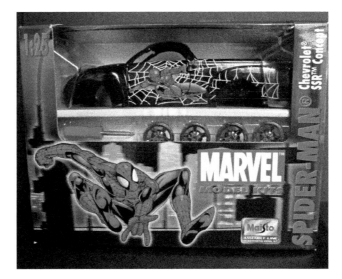

Spiderman Chevrolet SSR Concept pickup truck by Maisto in 1:25 scale. This kit is basically a standard but unassembled diecast model. Note the screwdriver.

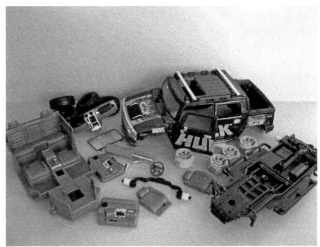

Parts for another Maisto kit, the Incredible Hulk Hummer H2 SUT Concept in 1:27. The body has been fully painted, and the opening doors installed. Just assemble, using the screwdriver provided.

Catalogue Numbers

Model numbering varies from company to company, and may change over the years. Some systems are very complex, and collectors have occasionally added their own prefixes or suffixes to keep track of everything. Generally, companies tend to group similar models together, and to assign a block of numbers to each. Some considered Star Cars to be a single group, while others split them up among passenger cars, emergency vehicles or aeroplanes, depending on the type of vehicle. Cartoon and comic-book models were often separate from film and television models. Some companies also reuse old numbers. Different versions of the same model may be given different numbers. The Corgi Volvo P1800 started out as 228; when it became the Saint's car, it was renumbered 258; and, when it received low-friction Whizzwheels, it became 201. Reference books covering a single make of model usually include a section on numbering.

Dates

The date on a model or box is not a reliable guide to when the model was actually made. Dates usually refer to the basic casting, and some companies are still producing models from the 1970s; or an old model may be reissued. It might also be a copyright date, not a release date. Dates on packaging may refer to the artwork, not the model. Some may be a licence or copyright/trademark date. The Corgi Classics reissues of several James Bond models from the 1990s also have '1962' on the boxes, which refers to the 007 and gun logo.

Screen Accuracy

'Screen accurate' means faithful to the vehicle as it appears on screen, including the correct vehicle type in relation to make, model, and year; the correct colours and markings; and any special fittings. Some models bear little resemblance to the vehicle they purport to represent, with the manufacturer simply using any vaguely suitable model they have available. Generally, toys have standard wheels, common to other vehicles by the same company, so they seldom match those on the screen car – but premium lines usually have more accurate wheels.

Sometimes a lack of accuracy is not the fault of the model company. The real vehicles used on screen can vary if several vehicles are used during filming, especially with a long-running television series. Cars can also be updated to a later production model each season, even if they are supposed to be the same vehicle, meaning details can vary. Generally, the car used for close-up work, and fitted with any gadgets, is considered the definitive version.

Sometimes the proper vehicles are simply not available. In the film *Battle of Britain* (1969), a lack of real German Stuka dive bombers led to several British planes being dummied up to look like Stukas. The Dinky Stuka model was based on the real aircraft, not the film version, making it historically accurate, rather than screen accurate. Some models are based on craft that simply do not exist in real life, such as the spaceships used in science fiction. These models are frequently based on special-effects miniatures, and are therefore models of models. More recently, there may not even be an effects model, as computer animation takes over.

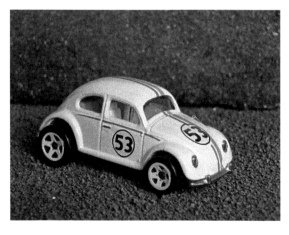

The Hot Wheels Mainline version of Herbie from *The Love Bug* (1969) is based on a customised vehicle – totally wrong for Herbie, who is a stock Volkswagen Beetle. 63 mm.

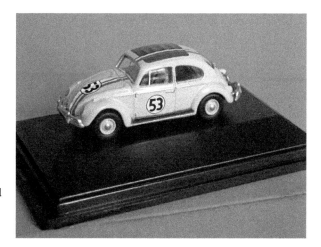

The Oxford Diecast version of Herbie in 1:76 scale is much more accurate, and comes in a plastic display case – here the top has been removed to show the model more clearly. 53 mm.

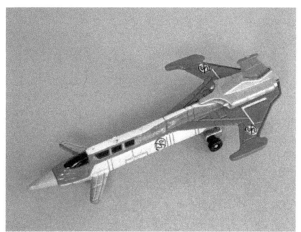

The Spectrum Passenger Jet from *Captain Scarlet and the Mysterons* (1967–68), by Vivid Imaginations. Like many Gerry Anderson aircraft, it has forward-swept wings. 111 mm.

Colours and Colour Schemes

Sometimes the colours applied to models differ from those used on the screen car – this may be done to reduce the amount of painting required, or because the scheme is considered too complex. *The A-Team* (1983–87) featured a group of Vietnam veterans on the run. They had a black van with a red stripe – although the roof was actually dark grey. Most models show the van as plain black. Few people ever noticed this, including me, and I watched the series in the 1980s. The original Corgi James Bond Aston Martin from 1965 was gold rather than silver. This is usually explained away as Corgi not wanting a silver model to look unpainted, which seems unlikely. Remember, the film was called *Goldfinger*, after the main villain; and it was about a bullion heist. What could be more logical than a gold car? Later models were mainly silver, with an occasional gold version to remind us of the original.

Other models have been finished in non-authentic colours in what seems to be an attempt to liven up the model. Dinky used metallic paints on several of their Gerry Anderson models. Johnny Lightning released many movie cars in non-authentic colours, in the hope that obsessive collectors would buy one of each.

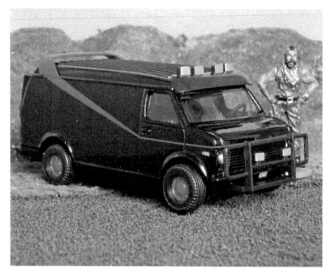

The stars of *The A-Team* (1983–87) were on the run in their custom GMC panel van. Like most models of this van, the 1:36 Corgi version is plain black with a red stripe – the roof should actually be dark grey. It came with a single resin figure. 127 mm.

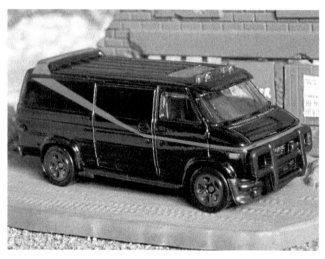

The small Hot Wheels Mainline model of the van made its debut in 2011. Again, the basic finish is black with a red stripe. 76 mm.

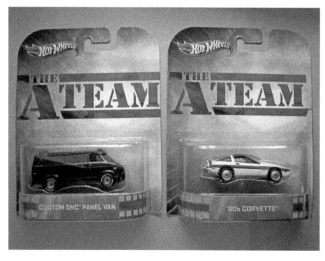

Hot Wheels Entertainment *A-Team* models. This time the van does have a dark-grey roof, and is joined by an '80s Corvette.

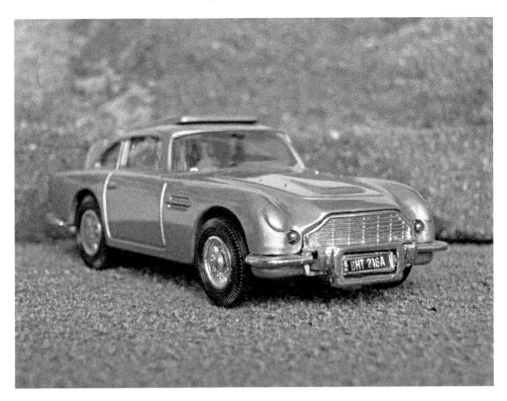

Above: The second Corgi DB5 from 1968 was usually silver, but some reissues were gold, like the smaller 1965 version. This model added revolving number plates and rear-tyre slashers to the features found on the original. 101 mm.

Right: The Fright'ning Lightnings series by Johnny Lightning contained various spooky models, such as the *Christine* movie car, but often in totally unauthentic colours, such as purple instead of red and white. A limited edition of 15,000.

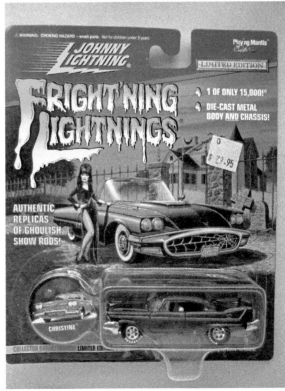

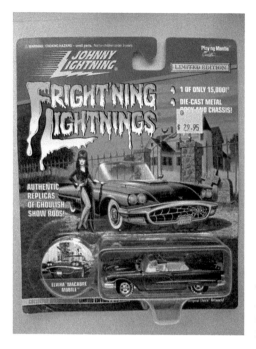

The Macabre Mobile from *Elvira – Mistress of the Dark* (1988) is another model in the wrong colours; it should be black rather than dark green. Elvira herself graces the card.

Decoration

It is not unusual for toys to have logos and titles that the real vehicle never carried on screen. This helps identify the vehicle as a Star Car, and brighten up an otherwise plain model. The Corgi version of the Saint's Volvo (and later his Jaguar) had his trademark stick figure, complete with halo, on the bonnet. This came in various colours over the years. The large *Man from U.N.C.L.E.* car carried the U.N.C.L.E. logo on the bonnet, or rather the hood, and cast into the baseplate. However few Bond cars had such extra markings, making them much more faithful to their screen counterparts. Some vehicles just carry titles or graphics related to the show.

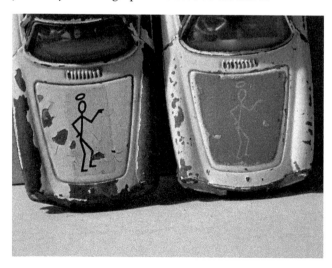

The Saint's stick-figure logo on the bonnet of the Corgi Volvo P1800 changed over the years, from a black-on-white decal to a white-on-red or white-on-blue sticker. The shape also changed. For *The Return of the Saint* Jaguar in the 1970s, it was back to black on white.

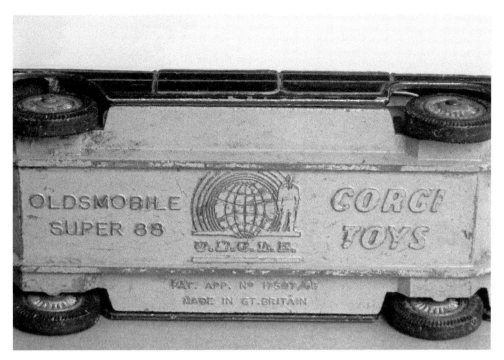

The Corgi *Man from U.N.C.L.E.* car was a modified Oldsmobile Super 88 sedan, with the U.N.C.L.E. logo cast into the base – no identification problems here.

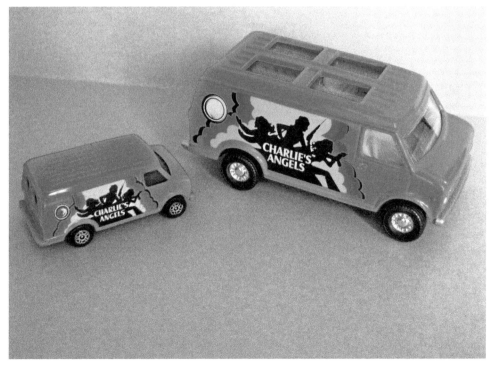

Charlie's Angels (1976–81) featured a team of female private eyes. Corgi did 1:36 and 1:64 vans based on the show. The roof treatments differed, and the large model has opening rear doors. 121 mm and 67 mm.

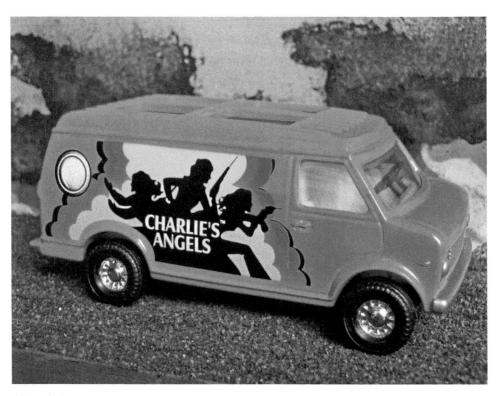

Although this van never appeared on *Charlie's Angels*, the spectacular side graphics are based on the opening/closing credits.

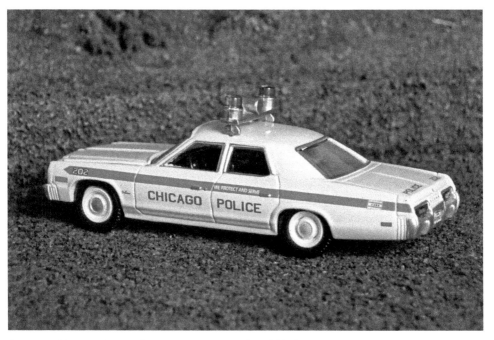

A pristine Chicago police car from *The Blues Brothers* (1980). Dodge Monaco by Greenlight, using the same basic casting as the Bluesmobile. 89 mm.

The Blues Brothers were on a mission to save their old orphanage and destroy every police car in Chicago. The Bluesmobile was a retired police car, this Greenlight model being well weathered.

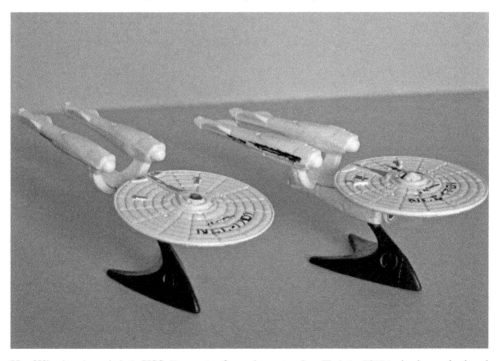

Hot Wheels released their USS *Enterprise*, from the series *Star Trek*, in 2013 in both standard and battle-damaged versions. Lacking wheels, the models have a display stand.

The Citroen 2CV picked up a few
dents during its escape scene in
For Your Eyes Only, and this is how
it was modelled in *The James Bond
Car Collection* partwork.

Decoration can be applied using paint, glued-on labels, self-adhesive stickers, or decals/transfers printed on thin film. Many modern diecasts have decoration applied by tampo printing. Fast-drying inks are applied to pads, which transfer the image to the model. Some models depict vehicles that are showing signs of use, such as mud splashes. Known as 'weathering', this technique is common in many modelling fields, but rare on diecasts. Damage too can be simulated with paint or tampo printing, but sometimes new parts are needed. This may be done to match a particular scene in a film.

Interiors

Except for open-topped cars, few diecasts had interiors prior to the arrival of plastic in the late 1950s. These could be moulded in any colour required, and some models came with a range of different interior colours. Since some also came in a range of exterior colours, there might be several different interior/exterior colour combinations. Some collectors try to obtain an example of each combination. Other models lack any interior. To hide this, the windows are often tinted, or made of opaque black plastic.

Wheels Type Obsession

Diecasts can have solid metal, plastic, or rubber wheels – or rubber tyres on metal or plastic hubs. Tyres can fall off, and rubber is likely to perish and split after a few decades, although modern replacements are available. Following the successful launch of Hot Wheels in 1968, with their low-friction wheels and axles, other companies were forced to switch to similar wheels, to the horror of many collectors. They regarded the new wheels as unrealistic compared to the older styles, which came to be known as regular wheels. Corgi adopted Whizzwheels; Dinky had Speedwheels; and Matchbox had Superfast. This change involved more than just a new wheel design. The wheels were wider, and so they needed larger cut-outs in the baseplate, and new axle mounts. Often, this meant a completely new baseplate. Hot Wheels in particular have used many different wheel designs over the years.

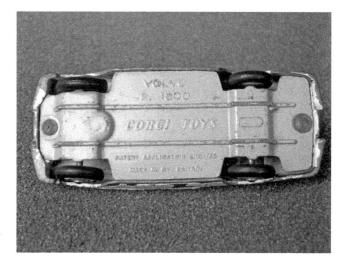

The Corgi Toys 258 Saint's Volvo P1800 with regular wheels has a metal baseplate, and separate rubber tyres, which may split over time.

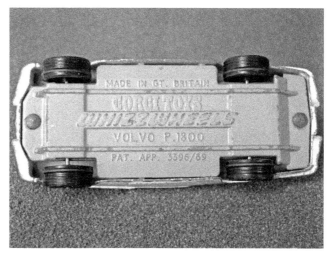

The 201 version of the Saint's Volvo has low-friction Whizzwheels, much thinner axles, and a completely new baseplate – no wonder it received a new catalogue number.

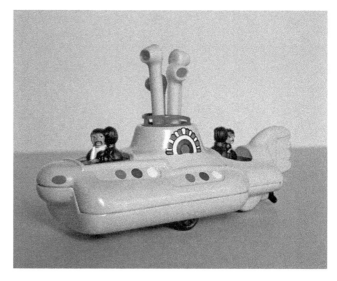

Yellow Submarine (1968) was an animated film starring The Beatles. The Corgi model has been reissued several times in different versions. Some have opening hatches and pop-up figures; closed hatches and no figures; or figures and no hatches. All run on concealed wheels. 115 mm.

Many vehicles do not normally have wheels, and models of them actually run on wheels hidden within the base, such as Corgi Juniors Popeye's Tugboat, Hot Wheels Flintmobile, and Hover Mode DeLorean from *Back to the Future*.

Collecting every possible variation has resulted in a disorder that I have termed 'Wheel Type Obsession', which is very common among Hot Wheels collectors.

Subjects that do not normally have wheels – boats, submarines, hovercraft, and some tracked vehicles – frequently run on concealed wheels. Aircraft and spaceships may not have wheels at all, but be mounted on display stands.

Figures

Early Corgi Star Cars all came with plastic figures. Most models had at least one or two, and some as many as four or five – the entire main cast. Even the small Husky/Corgi Junior models included figures. These were initially very well painted (Simon Templar, the Saint, is clearly wearing a bowtie), but later both the standard and extent of the painting declined. By the late 1970s, models were being issued without any figures at all. Much later, Corgi Classics began to include painted metal or resin figures with some models. These were usually to the common figure scale of 54 mm (1:32), which seldom matched the vehicle scale. Other companies also included figures with some of their models and, again, standards varied. Today, few Star Cars include figures.

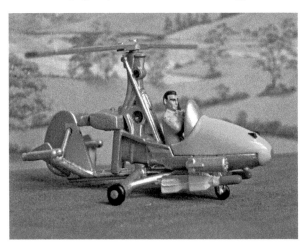

The small Corgi Wallis Autogyro Little Nellie from *You Only Live Twice* (1967) includes a figure of Bond with his arms crossed, based on the movie poster. 67 mm.

Partworks

Partworks are popular in Britain and Europe, but virtually unknown in America. You get a magazine containing information and a model, usually every fortnight. These are numbered, not dated, and there are often unnumbered 'Specials' containing larger models at a higher price. Most vehicles come in a plastic display case, sometimes on a scenic base. James Bond, Batman, and *Star Trek* have all been covered. This is an excellent way to build a collection at a reasonable price – but it may take several years to complete a set, and a successful partwork can have its run extended. Typically, only the first few issues are on general sale at magazine retailers, after which you have a place a standing order or take out a subscription. To encourage you to subscribe, there are often extra models or other exclusives. The first issue is generally sold at a reduced price.

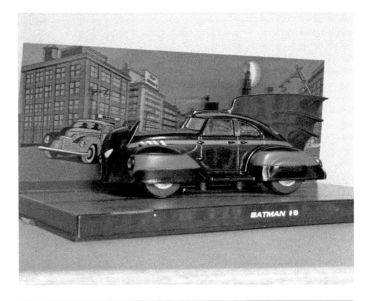

*Batman Automobilia –
The Definitive Collection
of Batman Vehicles* from
Eaglemoss included film,
television cartoon, and
comic-book Batmobiles,
including this one from
Batman comic #5. 126 mm.

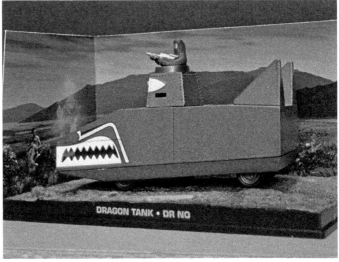

Dr. No (1962) was the first
Bond film, and several
vehicles from it appeared in
The James Bond Car Collection
partwork, including the
fire-breathing Dragon Tank,
all on scenic bases.

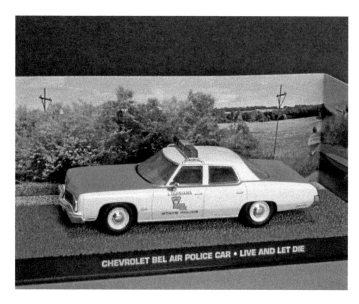

This Louisiana State Police patrol car was seen in *Live and Let Die* (1973), and was included in *The James Bond Car Collection*, posed on a simple stretch of roadway.

Special Features

One of the things that made the early Star Cars so memorable were their working features. There was the ejection seat in the Corgi James Bond DB5; spring-fired plastic rockets (usually red or yellow, so they would be easier to find in the carpet); extending wings, hydroplanes, or machine-guns that popped out at the press of a button; pop-up headlights; revolving number plates; or radar scanners that turned as the model rolled across the floor. The Dinky *Battle of Britain* movie Spitfire had a battery-powered spinning propeller. Many models had opening doors, or bonnets that lifted up to reveal a detailed engine. These features became less common in the 1970s, and some earlier models had existing working features eliminated. At most, modern adult collectables usually only have opening doors or an engine.

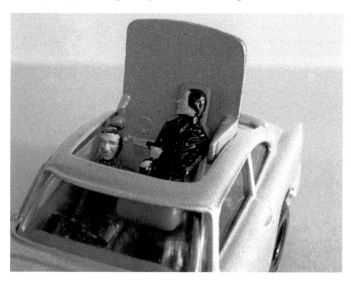

The Corgi 1:36-scale Aston Martin DB5 sends an unwelcome passenger into orbit. This ejection seat was probably the most famous working feature ever included on a model car.

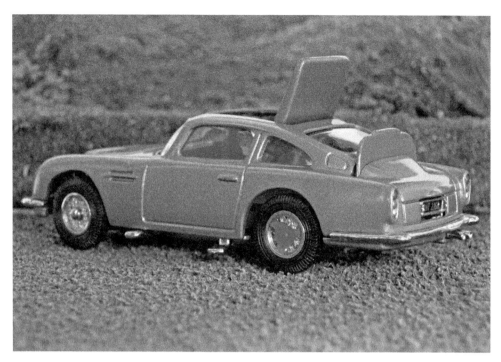

The second, slightly larger Corgi DB5 added pull-out plastic tyre slashers and revolving number plates to the original version's ejection seat, pop-up screen protecting the rear window, machine guns and front-bumper overriders.

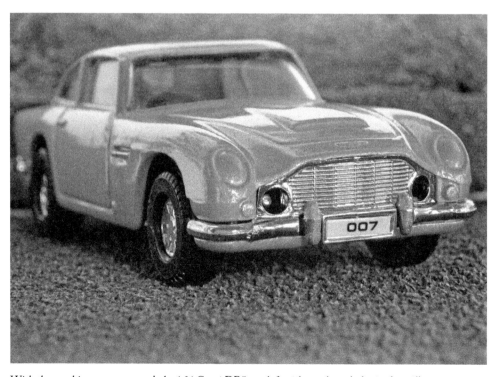

With the machine guns retracted, the 1:36 Corgi DB5 was left with two large holes in the grille.

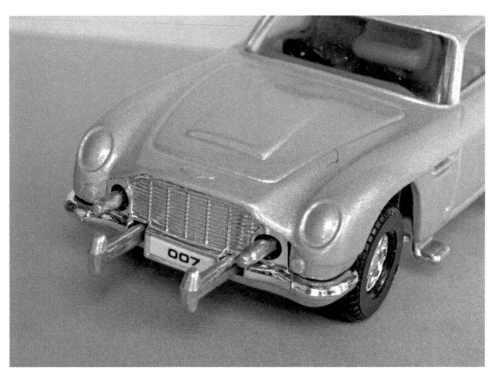

The 1:36-scale DB5 from 1978 moved the front machine guns from the wings to the grille, and omitted the revolving number plates and tyre slashers of the second version.

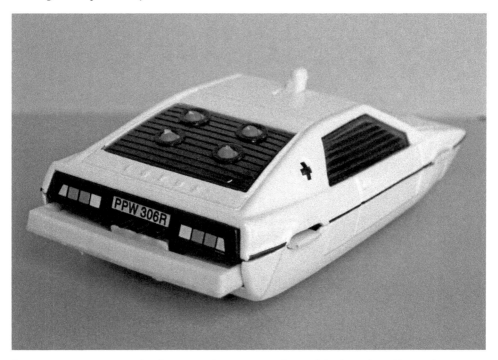

From *The Spy Who Loved Me* (1977), a twentieth-anniversary edition of the Corgi Lotus Esprit submarine car, with control surfaces retracted – 120 mm. There was also a Juniors version.

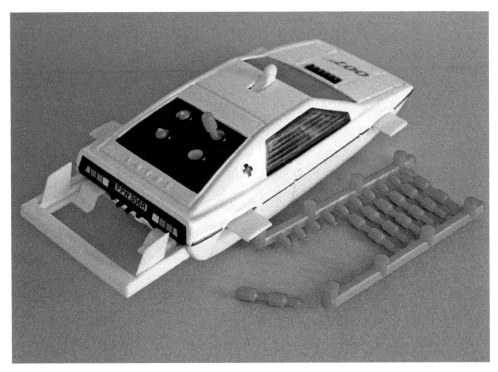

The Corgi Bond Esprit with underwater fins and hydroplanes deployed, and plastic missiles loaded. The model runs on concealed wheels. 136 mm.

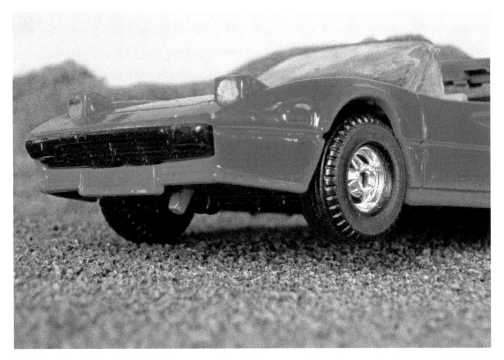

The large Corgi Ferrari 308GTS has pop-up headlights operated by a lever under the nose, and a lift-up engine cover at the rear.

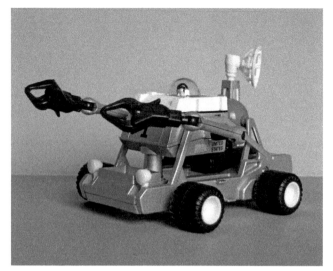

The James Bond Moon Buggy from *Diamonds Are Forever* (1971) was released in 1972. It has movable arms with claws that can actually grip objects. The radar scanner rotates as the model rolls across the floor. This is a later reissue. 115 mm.

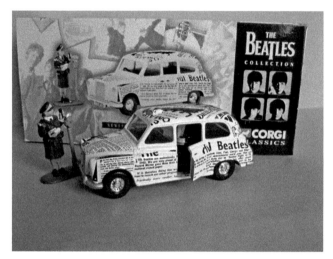

Part of the Corgi Beatles Collection from 1997 is this Austin FX4 London Taxi, with newspaper stories about the band, and a figure of Rita the Metermaid. The rear passenger doors open. This is not the same casting as the FX4 shown previously. 120 mm.

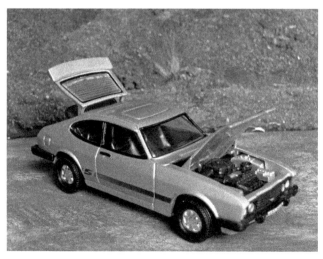

The Professionals (1977–83) featured CI5, a special Criminal Intelligence unit. This reissued Corgi Ford Capri has an opening bonnet and boot, and two metal figures. 121 mm.

Terminology

Some of the terms used by collectors have a special meaning within the hobby, different from their everyday meaning. 'Prototype' usually means the first example of a new vehicle or model, built to try out the design. To a modeller or collector, it can also be the full-size vehicle on which a model is based. 'Obsolete' is any model or variant that is out of production, and no longer available in shops – but a current model or variant is still available. This means a particular variant might be obsolete, but other versions of the same casting may still be available. A contemporary model is one made at the same time as the real vehicle. Metal parts are cast, while plastic is moulded. 'Self-coloured' refers to coloured plastics that do not need painting. The underside of a model is a 'baseplate' if it is cast metal, but a 'base' if it is plastic. 'Loose' is any model without its original packaging.

A diorama is a scenic setting in which to display a model. A few models, and several partworks, come with dioramas – or you can make your own. There is a vast range of items aimed at military and railway modellers, some of them ready painted, that collectors can use to make these displays. These photographs show a few examples.

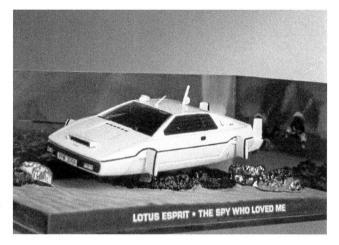

The Lotus Esprit submarine car from the Bond film *The Spy Who Loved Me*, in an underwater diorama. All the models in *The James Bond Car Collection* included such dioramas, although most depicted dry land.

Auric Goldfinger had a vintage Rolls-Royce in *Goldfinger* (1964), which Corgi included in their small-scale Bond range in the 1990s. Even the villain cars in this series had 007 number plates. Hills and roadways are easy to make from scrap materials. 90 mm.

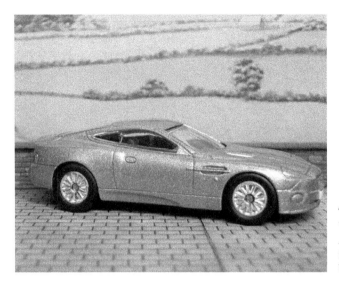

The small Corgi Aston Martin V12 Vanquish from *Die Another Day* (2002), in a simple setting in front of a printed model-railway backscene by Peco. 86 mm.

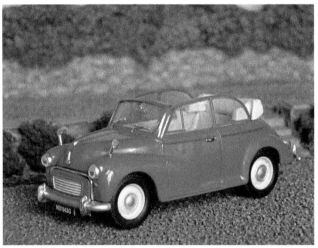

Lovejoy was a dodgy antiques dealer, with a Morris Minor convertible, modelled by Corgi. Stone walls and foliage make a suitable backdrop for any model. 86 mm.

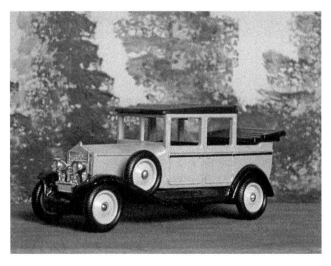

The 1926 Rolls-Royce Landaulet from the Lledo *House of Eliott* series, against a simple painted backdrop of trees – no artistic skill required. 87 mm.

Boxes and Box Art

Whatever you collect, the golden rule is – *keep the box*. Boxes protect models, and keep small items together. They often provide useful information about the model, including operating instructions for working parts. Designed to stand out on toy-shop shelves and help sell the model, boxes are often exciting and colourful, adding greatly to the appeal of the model. Sadly, many models aimed at adult collectors come in very boring boxes. Packaging styles change frequently, which can be a useful guide to dating. Books on the models of individual companies generally include a section on packaging. Some people try to collect all the different box designs, even if the models inside are identical.

Officially produced Star Cars nearly always come in special packaging, which identifies the film or television show the model is based on, even if there is nothing on the model itself. There may even be a brief history of the show, usually on the back of the box, but this is not always accurate. Not every Star Car comes in a box adorned with the title of the film or television show it is from. Some models come in standard boxes, but are nevertheless similar or identical to screen vehicles. This allows the manufacturer to avoid having to pay a fee to the film maker, but such anonymity is hardly going to boost sales. These are sometimes called 'unofficial' or 'hidden' Star Cars; others are simply similar to film cars.

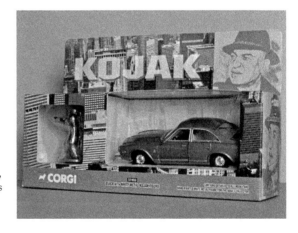

The reissued *Kojak* Buick Regal with figure, in a long window box. Boxes aimed at adults are often very dull in comparison with toys from the 1960s. 150 mm.

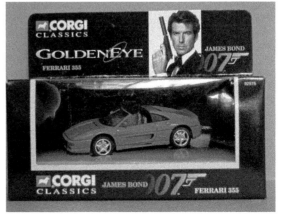

The first new Corgi Bond models since 1983 were released for *GoldenEye* (1995), including the Ferrari 355 villain car in 1:43; the companion DB5 was 1:36. 99 mm.

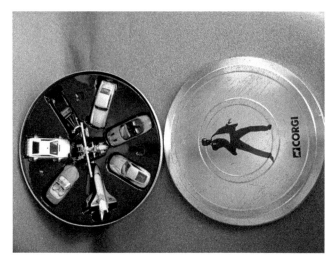

Very few models come in tins, but Corgi produced an eight-vehicle set in one resembling a film canister, with Mr Bond on the lid.

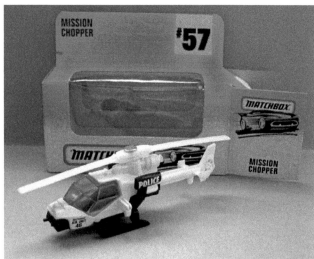

The film and television series *Blue Thunder* featured a high-tech police helicopter. The Matchbox Mission Chopper or Mission Helicopter was never released as an official *Blue Thunder* tie-in, and usually came in police or army markings. 94 mm.

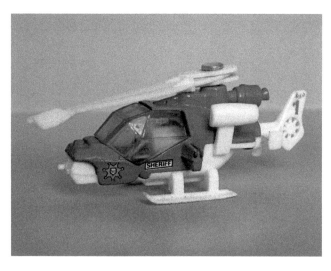

The Mission Helicopter tail boom telescopes into the fuselage; and the main rotor blades fold so that it will fit inside its box. Later examples had a smaller, one-piece main rotor.

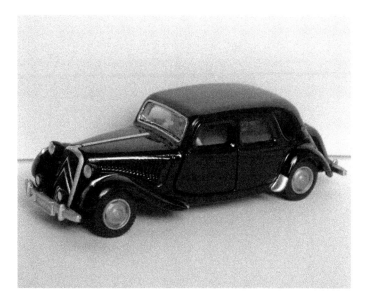

A normal Citroen Traction Avant by German company Siku, with opening doors. It is just like the one driven by French police detective Inspector Maigret on British television, so it is almost a Star Car. 85 mm.

Boxes with lift-off lids tend to be reserved for more expensive models. Most diecasts came in cardboard boxes, with long end flaps that tucked in, or short flaps that are glued down. These have to be carefully opened with a letter opener or knife, but can not be resealed. Introduced in the 1960s, and common by the 1970s, was the window box, which allowed the model within to be seen. Dinky used a cardboard plinth, covered with a clear-plastic bubble. Others used a hard-plastic display case – these are virtually standard among partwork models.

Smaller models often come on cards with a clear-plastic bubble or blister glued to the front. Usually the only way to remove the model is to cut through the bubble on three sides, leaving the top or bottom as a hinge. Once opened, they can not be resealed. If you want to display your models, but still keep the packaging intact, you will have to buy two.

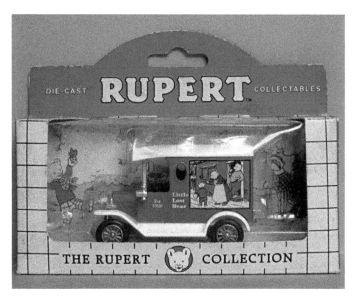

Rupert Bear first appeared in the *Daily Express* newspaper in 1920. Lledo released the Rupert Collection of models, carrying Rupert artwork; they included this 1920 Ford Model T Van. 69 mm.

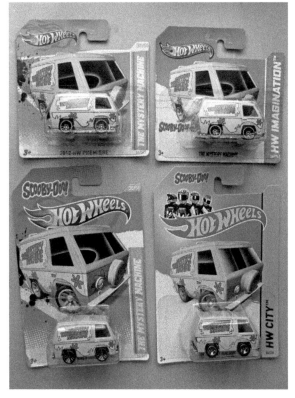

Above: Lledo (and Corgi) had a range of models featuring artwork from British weekly comics and their major characters. This is Korky the Cat, from *The Dandy*, on a 1959 Morris LD150 Van. The box has a hinged flap covering the small plastic window. 84 mm.

Left: A selection of Hot Wheels cards, showing packaging variations for a single model: the Mystery Machine van from *Scooby Doo*. The long cards are more common.

Identification

Models without boxes pose several problems. Among these is the difficulty of determining whether the model is actually a Star Car. If you have a Batmobile, a model with Superman on the side, or Mickey Mouse at the wheel, then clearly it is a Star Car. Unfortunately, there are lots of models that are very difficult to identify as Star Cars unless you recognise the subject. The Corgi Ferrari 308GTS from 1982 is particularly difficult. Exactly the same model was released in a normal Corgi box, and as the *Magnum P.I.* television car. Without the box, there is no way to tell them apart – honestly, my example could be either.

Turning a model over should help to identify it. Usually there will be the name of the manufacturer, and where it was made. Sometimes there will be the name of the vehicle, a date, the scale, even a catalogue number. With Star Cars, there will often be a copyright notice for the company that owns the character or vehicle design. It is unlikely that all this information will be included on any single model, but there should be something – although there are always exceptions.

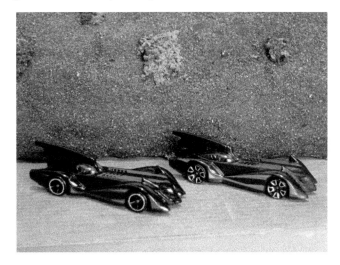

There have been numerous Batman cartoons, each with its own Batmobile design; *The Brave and the Bold* car had a Bat-shaped nose. Hot Wheels colour and wheel variations. 82 mm.

Corgi used both their large and small Chevrolet Van/US Van models for several Star Cars, including this Juniors Superman version. There is no interior; instead, the windows are tinted.

Mickey Mouse in a 1930s-style roadster. There is no maker on the base, just © Walt Disney Productions. It is made in Japan, not a country usually associated with diecast models. 61 mm.

Magnum P.I. (1980–88) was a private investigator based in Hawaii, who drove a Ferrari 308GTS. The Corgi model has a black plastic interior, with tan-coloured seats. Using self-coloured plastics means that no painting is needed. 122 mm.

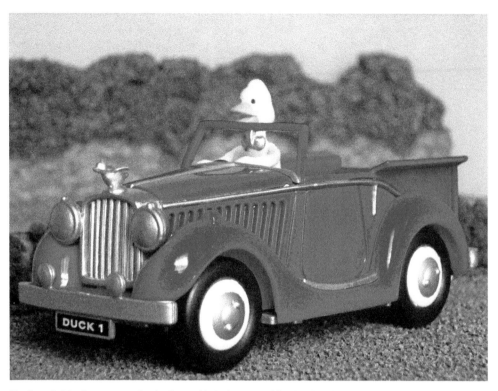

Duck in the Truck is a picture book, first published in 1999. This book and toy gift set from HarperCollins is dated 2004, but there are no markings on the model itself to identify it, or its driver. 102 mm.

Reading for Collectors

The more you know about your subject, the more you will enjoy the hobby. There are numerous books and price guides on diecasts – some general, some covering the products of a single company in detail. The big names of Corgi, Matchbox, Dinky, and Hot Wheels are well covered, but even the smaller firms usually have at least one book apiece. There are monthly magazines such as *Model Collector* (who publish an annual *Model Price Guide* covering British makers) and *Diecast Collector* to keep you up to date.

There have been several books on full-size Star Cars. As many of these were the work of major car customisers – George Barris, Dean Jeffries, and others – books on their work include many examples. Then there are books on the cars of James Bond, Batmobiles, or the spaceships of *Star Trek*. Books on individual films or television shows often include a chapter on the vehicles, although the coverage varies.

Condition

To collectors, condition is extremely important, and greatly affects the price of a model. Mint in box is the ideal, but such models can be extremely expensive when it comes to vintage toys from half a century ago. If you do not mind models that show a

few signs of wear, or that are unboxed, there are some very good buys to be had. When buying any model, especially second-hand, always check for damage, missing parts, repairs, or repainting. The more models you have the chance to examine, the easier it becomes to spot problems. Chrome plating does not wear as well as paint, and rubs off easily. An otherwise perfect model may be marred only by worn bumpers or wheel hubs, showing the coloured plastic beneath.

Like all forms of collectable, there is an established system of grading both models and boxes, although the terms used can vary slightly. Generally it is assumed that the model is complete, with no broken or missing parts.

Mint – perfect, just as it left the factory.
Excellent or Very Slightly Chipped – close to mint, but with slight signs of wear, or small chips.
Good or Slightly Chipped – showing more signs of wear, but still presentable.
Fair or Chipped – definitely showing signs of use, heavy paint loss, and other flaws.
Poor – really poor, with little original paint left.

'Playworn' refers to any model that has obviously been played with. A repaint is a model that has a fresh coat of paint over the existing finish, or the model may have been disassembled, stripped, painted, and reassembled. 'Restored' covers anything from a simple repaint to the repair of damage or the replacement of missing or damaged parts. A conversion is a model that has been altered in some way, not just repainted. There are now a number of small companies making replacement parts for models, or it may be possible to adapt leftover kit parts from a previous project. There are also companies making reproduction boxes for models that have lost their original packaging. The use of replacement parts or boxes means that the model is no longer as it left the factory, even if the restored model looks better than it did unrestored.

Variations

Sometimes seemingly identical models are actually different in some small way: wheels; interior colour; window colour; a casting change; or the base may say 'Made

A pair of Hot Wheels Batcopters. The design of the main rotor hub, and the way the rotor attaches to the model, differs slightly. 84 mm.

in England' on one model, and 'Made in China' on another. Some collectors try to track down every possible variant. However, on some models parts are easily changed around; and, in these cases, it is easy to create rare combinations, or even combinations that never existed. Such models do not generally command much of a premium, if any at all, when compared to those that would be difficult or impossible to fake.

If a Star Car was used in more than one film, a single model can be put into a different box for each film, thus creating a 'different' model, even if the vehicle is identical. Usually, however, there will be small differences so that collectors can tell them apart.

Where to Find Your Models

If you are just starting out in collecting, step one is to find some models. Do you still have any of your childhood toys? If so, there may be a few Star Cars among them that can form the basis of your new collection.

Current toys can be found in toy shops and toy departments, but the selection of special ranges, such as the Hot Wheels Entertainment series, is usually limited. These models tend to sell out fast – so grab them while you can, although this really applies to any type of Star Car. Model shops have more specialised lines, and some also carry second-hand models. Comic-book and pop-culture shops are very expensive, as are antique shops. At the opposite extreme are pound shops and $2 stores. There are also flea markets, known in Britain as car-boot sales. School or church fundraising fairs always have a toy stall – head to this first, as toys go really fast, but do not expect to find anything 'Mint in Box'. Charity shops are another possible source. Mail order is still around, but you do not get to actually see the models you are buying. There are also auctions, either real or on the internet.

The best place to find older models is at a collectors' fair. Most are regular events. They can be overwhelming at first, but are well worth a visit. Regard your first few fairs as an education in what is available, and conditions and prices. Few traders specialise in Star Cars, but most tables will have a few examples. Here are a few tips that will make life easier. Check that the show is still on, especially if you have to travel a long way. If you rely on public transport, check this out beforehand. The earlier you arrive, the better the selection. Some fairs offer free entry late in the day but, by then, the selection will be poor, and many sellers will already be packing up. Save up your small notes and coins, as stall holders rarely have much change, and few accept electronic payment. Bring a large bag with plenty of plastic supermarket bags for wrapping and protecting models. Set yourself a budget, and try to stick to it – there will always another fair. Many stalls have a junk box, often under the table itself, full of oddments and playworn models. This is always worth a look. Some of the models in this book came from just such a box.

Care and Display

Models should be kept out of the sun, but prolonged exposure to any source of light can fade paintwork, decals, and boxes. Always be careful when handling or dusting models. Decals and stickers, especially on older models, can become very fragile. Plastic parts become hard and brittle, with clear parts being prone to scratching. Even the clear plastic used for bubble packaging yellows and becomes brittle with age.

Ideally, models should be displayed in a glass display case or china cabinet, rather than on open shelves. The models will be protected from dust, pets, and other hazards. There is one problem with model vehicles that is seldom encountered with other collectables: most have wheels, meaning they can run off a shelf and plummet to the floor below. A raised lip at the edge of the shelf; strips of wood glued to the shelf to hold the cars in place; a non-slip surface; or even just something under the body to raise the wheels off the surface – all these things will help to protect the models. Diecasts are heavy, so make sure your shelves, and their supports, can take the weight. Often, shelves rest on just four plastic pegs, which can shear off. Either buy better-quality furniture, or replace the plastic pegs with metal pegs from a hardware shop.

When not on display, models should be kept boxed and packed away in cartons or a cupboard. Loose models can be given a new home by reusing household packaging. Try to avoid excessive heat, cold or changes of temperature. Keep the models somewhere dry – dampness and models do not mix well.

Cleaning

Any cleaning must be done gently – it is better to do nothing than to risk damaging a model. For dusting, use a soft artist's paint brush, soft make-up brush, or puffer brush. The latter is used for cleaning camera and computer equipment. Never use a normal duster on a model.

If a model needs more cleaning, a damp (never wet) cloth or cotton bud can be used. Only use warm water with a little dish-washing liquid. Never immerse a model in water, and avoid getting decals or stickers damp. Never use abrasive clearers. Gently dry the model with a soft cloth. Paper and card should not be washed. Restoring old and damaged diecasts is a specialist subject, and there are books on caring for antiques and collectables, some of which applies to models.

Carpet fibres may be wound around the axles of old toys. Cut through these with a sharp modelling knife, and use tweezers to remove the cut fibres. Price stickers can be

carefully peeled off with a fingernail, although it is often better to leave these, rather than risk tearing the box. Sticky residue can be removed from a glossy surface with eucalyptus oil (contained in some laundry liquids) or methylated spirits, but these can also remove inks. Trying to remove a sticker from a matt surface will certainly cause damage – leave it alone.

The Models

James Bond has been the king of diecast Star Cars since the beginning, the ultimate Bond car being the Aston Martin DB5 'with modifications'. Corgi covered most of the films, although Matchbox took over briefly in the 1980s. Corgi were back from *GoldenEye* (1995) onwards. They also reissued many of their existing Bond models. Johnny Lightning and Hot Wheels have both produced small-scale Bond cars. *The James Bond Car Collection*, which began in 2007, was a magnificent partwork from Eaglemoss, running to well over a hundred issues. Each model came in a clear-plastic display case, housing a small diorama. Best partwork ever.

As far as model Star Cars are concerned, Batman is second only to James Bond. Unlike most superheroes, he does not have any superpowers, and actually needs the Batmobile to get around Gotham City. Corgi, ERTL, and Hot Wheels have been the major producers; and there was a partwork by Eaglemoss. Other superheroes have also been covered, most being standard models with suitable graphics, although a few have had their own vehicles.

Celebrity cars are vehicles owned or driven by someone famous, but not used on screen, or that carry artwork depicting a celebrity, as do many music-related models. Character cars are generally not based on screen vehicles, but simply depict a fictional character, or come with a suitable driver figure. In most cases, the figure is more important than the vehicle, and most seem to be aimed at younger children. There are always exceptions, with some models depicting monsters from various horror movies.

Bond villain car, the Jaguar XKR from *Die Another Day*. Small-scale Corgi model with armament, including a rear-mounted, black-plastic Gatling gun. 92 mm.

In *Batman Begins* (2005), the Tumbler is a military prototype before becoming the new Batmobile, a fact that has allowed Hot Wheels to release both versions. 63 mm.

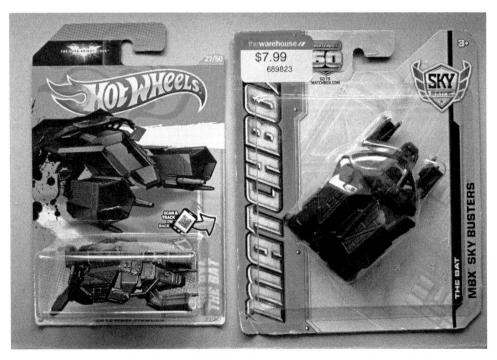

The Bat is a vertical take-off and landing (VTOL) jet from the *Dark Knight* films. Despite both being owned by Mattel, the Matchbox Sky Busters and Hot Wheels versions are different castings.

British comedy actor Peter Sellers owned the full-size version of this Oxford Diecast Mini in the 1960s, a customised luxury model. 41 mm.

From France, the Solido Signature Series featured American film stars. The 1:43-scale range had their signatures on the doors, while a larger-scale series added their portraits to the bonnet. This is the James Dean Buick in black.

The Solido Marilyn Monroe 1950 Buick Convertible is the same casting as the James Dean model, but in pink, and with red lipstick prints. 119 mm.

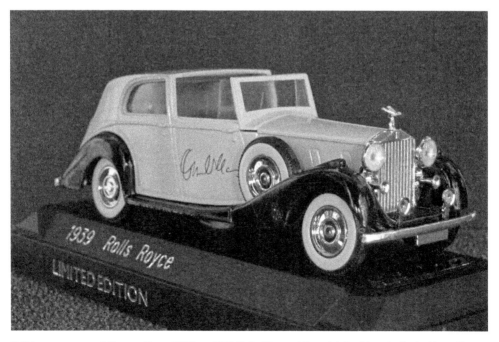

Solido gave actor and director Orson Welles a 1939 Rolls-Royce. All models in this series had whitewall tyres. 128 mm.

Solido Signature Series 1937 Packard Sedan, carrying the name of classic screen tough-guy Humphrey Bogart. 132 mm.

The Lledo Forces Sweethearts collection featured head-and-shoulders portraits of film and recording stars from the Second World War, all shown on a 1935 Morris Parcels Van, in different colours: Betty Grable – blue; Dorothy Lamour – light grey; Marlene Dietrich – green; Rita Hayworth – sand; and Vera Lynn – red. 92 mm.

Classic comedy team Laurel and Hardy spanned both the silent and sound eras. The short-lived Gate only produced a couple of Star Cars; both involved putting plastic figures in a standard US Army Jeep. 107 mm.

The *Peanuts* comic strip first appeared in 1950. Snoopy the Beagle got his own motorised doghouse from Hot Wheels in 2014, which has been issued with different wheels. 45 mm.

Super glamorous Miss Piggy from *The Muppet Show* (1976–81), in her pink Corgi roadster. There were three other models in this series: Kermit the Frog, Fozzie Bear, and Animal. 101 mm.

Action shows use a range of vehicles, from stock police cars to Ferraris. Few have any special features, beyond opening doors or an engine. Villains usually had to make do with whatever they could find in the toybox.

Concept cars are built by automakers to show what cars of the future might look like; they are not intended to actually go into production. Several have appeared in films or on television. Most concept models are only available for a relatively short period. Even if these do not come in official Star Car packaging, at least the basic vehicle is the same. Custom cars and hot rods, mostly modified production vehicles, can also turn up on screen. Some of these too are available in model form, but not always in the right colours.

Cartoons were originally screened in cinemas, before finding a new home on television. Over the years, several live-action films and television shows have been turned into cartoons; and some cartoons have been turned into live-action films, meaning that some vehicles exist in both forms. Many cartoon-based models are character cars, some with plastic figures. Others are standard models covered with graphics that depict animated characters. Much the same applies to comic-book, comic-strip, and video-game models.

The world of science fiction models is dominated by *Star Trek*, *Star Wars*, and the puppet shows of Gerry Anderson. Sometimes there is a certain amount of overlap with other types of film, with spacecraft appearing in several Bond movies.

Miami Vice (1984–89) was another undercover cop show with exotic wheels. Hot Wheels Ferrari F512M was 'for the adult collector', according to the back of the card.

Demolition Man (1993) is set in 2032, and uses several General Motors concept cars to depict the vehicles of tomorrow, including the GM Ultralite. Hot Wheels did both standard and Star Car versions, this being a regular model. 72 mm.

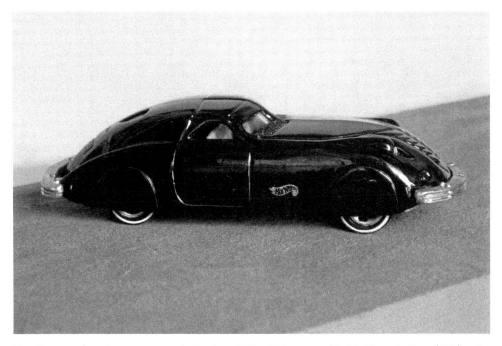

The Phantom Corsair was a custom design from 1938, which appeared in *The Young in Heart* (1938) as the Flying Wombat! Hot Wheels released their model in 1999, but not as a Star Car. The model came in various colours, with gloss black matching the screen car. 84 mm.

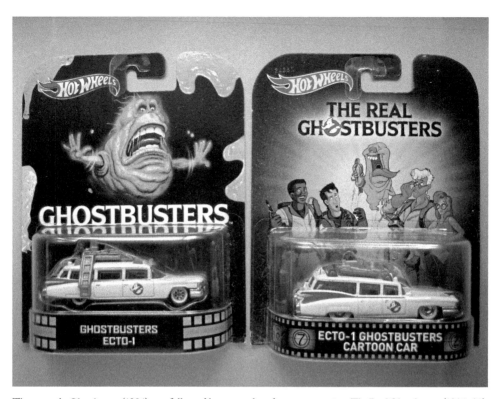

The comedy *Ghostbusters* (1984) was followed by a sequel, and a cartoon series: *The Real Ghostbusters* (1986–92). Hot Wheels went to the expense of producing both the real and cartoon versions of Ecto-1, their converted Miller-Meteor Cadillac ambulance.

In the computer-animated *Cars* (2006), all the characters are vehicles, including Sally, a Porsche 911 Carrera. All the vehicles are slightly dumpy caricatures, but still recognisable. 72 mm.

Hot Wheels added suitable graphics to their Cool-One van for the video game *Super Mario Brothers* (1985). There was also a six-vehicle set in the premium Pop Culture series. 63 mm.

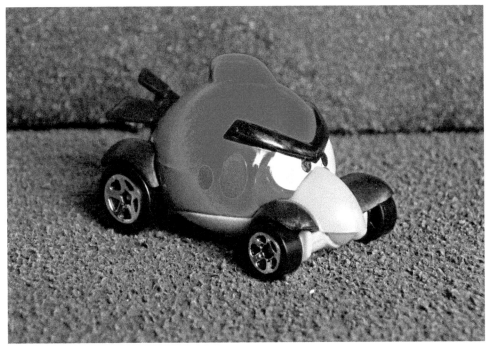

The video game *Angry Birds* saw Hot Wheels produce two models in 2012: Red Bird and the green Minion Pig, long before the movie came out in 2016. 53 mm.

The *Star Wars* saga began a long time ago, in 1977. There have been several diecast lines, including one by Hot Wheels. Their Millennium Falcon sits atop its display stand. 86 mm.

Captain Scarlet and the Mysterons (1967–68) saw global security service Spectrum battling ghostly Martians. This is the Matchbox-sized Spectrum Patrol Car from Vivid Imaginations, with a lift-up rear engine cover. 77 mm.